A History of the Narragansett Tribe of Rhode Island

D1453257

A History of the Narragansett Tribe of Rhode Island

KEEPERS OF THE BAY

ROBERT A. GEAKE

THE
History
PRESS

Published by The History Press
Charleston, SC 29403
www.historypress.net

Cover images: Topographical chart of the *Bay of Narragansett* (1777). *Courtesy of the John Carter Brown Library at Brown University*; photo of powwow by James Allen.

First published 2011
Second printing 2013

Manufactured in the United States

ISBN 978.1.60949.258.8

Geake, Robert A.
A history of the Narragansett tribe of Rhode Island : keepers of the bay / Robert A. Geake.
p. cm.
Includes bibliographical references.
ISBN 978-1-60949-258-8
1. Narragansett Indians--History. 2. Narragansett Indians--Government relations. 3.
Narragansett Indians--Social life and customs. I. Title.
E99.N16G43 2011
323.1197'344--dc22
2011005778

This book is dedicated to the memory of "Ickey" Francis E. Brown.

Contents

Part III: The Return of Sovereignty

Acknowledgements

This history, as with any other could not have been written without the research and published accounts of earlier historians, as well as those oral historians in the Narragansett tradition who have spoken to us. I would encourage readers as well to visit Tomaquag Museum and attend the public powwows when offered, to learn more about the tribe.

I want to acknowledge the courtesy of John Brown, the Narragansett tribe's preservation officer for reading and discussing the manuscript with me, as well as those members I have met over the years who have given me a glimpse into their lives, and thus, the stoic dignity that I will always see an indelible mark of their people.

In researching this book, I had immeasurable help from librarians and staff of the John Carter Brown Library and the Hay Library at Brown University, as well as the Rhode Island Historical Society and the Providence Public Library.

I want to thank especially, Leslie Tobias-Olsen of the John Carter Brown library, and Ms. Lee Teverow and J.D. Kay of the RIHS, Richard Ring of the Providence Public Library, and Paul Campbell, Archivist for the City of Providence, for their assistance. I also want to thank Dr. Patrick Conley.

And finally, this book would not have been written without the support of my family and friends, as well as those acquaintances who have patiently answered questions, read parts of the manuscript, and lent their support.

I want to thank Ted Widmer, director of the John Carter Brown library for his encouragement, Professors William Simmons and Linford Fisher for their reading and conversation, as well as local historian Henry A.L. Brown, and author J. North Conway for encouraging me to send the manuscript to the History Press.

Part I
KEEPERS OF THE BAY

Chapter 1
Early European Encounters

N arragansett oral history tells us that the aboriginal people of Rhode Island have existed, in Sachem Canonicus's words, since "time out of mind." Anthropological evidence shows that as far back as thirty thousand years ago, the tribe lived in the forests and along shoreline of southern New England, subsisting on hunting, gardening and gathering from the abundant resources available in their homeland.

At the period of their greatest authority, the Narragansett had a domain that extended throughout most of what is now Rhode Island, from Westerly in the southwest to about Pawtucket and the Blackstone River valley in the northeast, and also included Block Island offshore and Conanicut Island in Narragansett Bay.

Narragansett sachems ruled extensive territories by their authority respected beyond traditional homelands, holding considerable influence over the Nipmuck, Pokanoket, eastern Niantic and other remaining tribes of the area. At the peak of this authority, the tribe's population was reputed to be as high as thirty-five to forty thousand.

In communities throughout southern New England, these Native Americans predominately grew corn, beans and squash though also hunted deer, beaver, fowl and sea birds, as well as fished and harvested clams and oysters from the bay. Early tools were made from shells or soapstone that had been quarried from stone outcroppings on their lands, including sites identified in Oaklawn and Neutaconcanut Hill. The Narragansett also obtained wealth from the shores in the way of "Wampompeage," or

wampum, as it came to be known to Europeans, harvesting the unlimited resources of shells from the bay and fashioning the pearl-like interiors of whelks and the purple shells of the quahog into a currency that was used up and down the eastern seaboard. William Wood wrote in an early description that the Narragansett were "Mint-masters," so skilled in their manufacturing that English attempts at producing counterfeit currency were dismal failures.

The origins of the Narragansett people have been debated for at least three centuries; however, William Simmons related the earliest known reference from oral history to a "great sachem" named Tashtasick. It was the eldest grandson of this sachem, known as Canonicus, who would befriend Roger Williams during the period in which the tribe is most recorded.

Narragansett members called the first Europeans they encountered "Chauquaquock," or "knife-men," and were quick to recognize the advantages of trading for the iron axes, knives and hoes that these visitors brought to their shores. Despite the initial eagerness to deal with the newcomers, there is no doubt that the English who would eventually colonize the Narragansett country interrupted a successful way of life that had formed over many generations.

The first European record of the tribe came from the visit of Giovanni da Verrazzano, who spent fifteen days with the Narragansett during his journey up the Atlantic seaboard in 1524. His letter to Francis I contained an early description of Narragansett Bay:

> *The coast of this land runs from west to east. The harbor mouth faces south, and is half a league wide; from its entrance it extends for XII leagues in a northeasterly direction, and then widens out to form a large bay of about XX leagues in circumference. In this bay there are five small islands, very fertile and beautiful, full of tall spreading trees…Then, going southward to the entrance of the harbor, there are very pleasant hills on either side, with many streams of clear water flowing from the high land into the sea.*

The Narragansett welcomed the visitors, as was their custom, boarding their ships bearing gifts and leading them back to their homes for feasting and entertainment. Tribal history records that the explorer was greeted by Tashtasick and by Canonicus, who was then a young man.[1] Verrazzano described the tribe as "the most beautiful and have the most civil customs

that we have found on this voyage." He was much taken by their appearance, describing the men as "taller than we are; they are a bronze color, some tending more towards whiteness, others to a tawny color. The face is clear-cut, the hair is long and black, and they take great pains to decorate it; the eyes are black and alert, and their manner is sweet and gentle."

He was also much taken by the appearance and manners of the women, writing that

> [t]*heir women are just as shapely and beautiful; very gracious, of attractive manner and pleasant appearance...they go nude except for a stag skin embroidered like the men's, and some wear rich lynx skins on their arms; their bare heads are decorated with various ornaments made of braids of their own hair which hang down over their breasts on either side.*

While writing of their generosity and hospitality, he did note, however, that they held extreme caution with regard to their "womenfolk": "They are very careful with them, for when they come aboard and stay a long time, they make the women wait in the boats; and however many entreaties we made or offers of gifts, we could not persuade them to let the women come on board ship."

It is perhaps telling in this fact that the Narragansett so carefully guarded their women. Verrazzano was likely not the first European encountered, nor the first to admire native women, and earlier encounters with trappers and traders from France, England and Canada, as well as Dutch fishermen, may have resulted in interracial relations, normally frowned on by Native Americans at this time,[2] who saw their bloodlines as something that should be pure and protected. Nonetheless, the prospect of trade and commerce enjoined the Narragansett, like other tribes surrounding them, to continue to welcome Europeans and the goods brought with them.

Around 1570, however, less than fifty years after Verrazzano's visit, a devastating illness took what was estimated by the tribe's preservation officer to be 80 percent of the population of the Narragansett at that time. It was a forewarning of plagues to come, and as tribes along the East Coast of America suffered these afflictions, the white visitors took full advantage of the devastation. Another early visitor to Narragansett shores was the Dutch trader Adrian Block, who skirted the island that would later bear his name and

slipped into Narragansett Bay to locate the tribe that he called the Nahican; the Dutch were already familiar enough with the area to distinguish between the Narragansett, whom he found on the western side of the bay, with the Wamponec, or Wampanoag, the neighboring tribe.

By the early seventeenth century, the Narragansett still remained somewhat isolated from European settlement. Canonicus's famous "gift" of arrows in a snakeskin given to the Pilgrims at Plymouth signaled an early resistance to any white intentions of settling on Narragansett lands. This proved to be of considerable fortune when the first epidemic of smallpox swept through New England beginning in 1629. By 1634, Narragansett people had lost up to seven hundred of this generation of the tribe, but this was a small loss compared to the desolation wreaked by the outbreak on neighboring tribes in New England.[3]

These encounters indicate that at the time of Roger Williams's fabled landing on their shores, the Narragansett were as familiar with white visitors as Williams was with the native language. The circumstances of his stepping ashore from the wide cove at the eastern edge of what would become the settlement of Providence preceded an unprecedented period of political turmoil for the Narragansett. In time, it would matter little that Williams proved to be a friend and defendant of their rights. Their acceptance of the white visitors exiled from Massachusetts was the beginning of an encroachment that would bring the tribe to the edge of extinction.

Williams had entered the wilderness of New England as a trader and a missionary, learning the language of the Algonquian tongue by listening and taking meticulous notes. In time, Williams came to a singular understanding of the Narragansett exceeding any prior Jesuit, Puritan-oriented minister or, perhaps, white visitor to the tribe. It was his view as a separatist and his long-growing idea of "liberty of conscience" that allowed him to glimpse the nobility of Narragansett life and portray that life with an undiminished admiration for its virtues.

Much has been written and mythologized concerning Williams's banishment and his arrival on the shores of Rhode Island. This mythology comes partly from Williams's own writings, which were published years after the events. Having been sentenced to banishment on October 19, 1634, he almost immediately fell ill and, after recovering, delayed his exile until January 1635, when he received word from Governor Winthrop that a

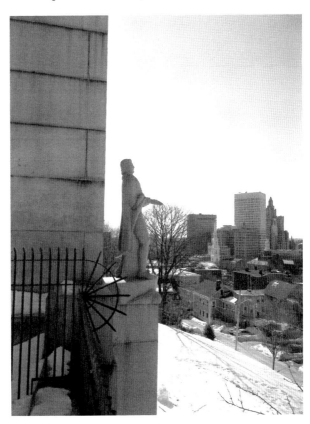

The Roger Williams Monument in Providence, Rhode Island. *Photo by author.*

group of magistrates was en route to arrest him and expedite his return to England. According to Williams's own account, Winthrop advised him explicitly to "go into the fertile, comely, and as yet unsettled Narragansett country." Williams's description of his flight as "[e]xposed to the mercy of an howling wilderness in frost and snow…sorely lost for…fourteen weeks, in a bitter winter season, not knowing what bed or bread did meane" is somewhat misleading.

From Henry Martyn Dexter's early, meticulous research, we know that Williams entered exile not alone but rather with four companions, two of the men being John Smythe, a miller from Dorchester, and William Harris, who would write his own pamphlets on religion once in the safe haven of "New Providence." Moreover, as Williams lay recovering from illness with the certainty of exile looming, "some of his friends went to the place appointed before hand, to make provision of housing, and other necessaries for him

against his coming."[4] This reportedly included at least three more men and eight women, all of whom were undoubtedly dispatched to the land that Williams had purchased years before from Ousamaquin to begin a new colony. According to Dexter, Williams "most likely...went as quickly as he could to Sowams [Warren, Rhode Island] the home of his friend Massasoit (Ousamaquin)."[5]

We know, as mentioned before, that Williams was already acquainted with the neighboring Wampanoag, Niantic and other smaller tribes and that while in Plymouth he had written a "treatise" that had caused some consternation among officials, namely Plymouth governor Bradford, who was already wary of Williams's "strang opinions." The treatise was brought to the attention of the authorities, and in December 1633, a meeting was held to pass judgment on the document. The panel included Massachusetts Bay Colony governor John Winthrop, whose journal recorded that "wherin, among other things, he disputed their right to the lands they possessed here, and concluded that, claiming by the King's Grant, they could have no title, nor otherwise, except they compounded with the Natives."

More to the panel's displeasure, however, than this signature claim of Native American rights were the slanders against the English King Charles II. Unfortunately for historians, any copies of the "treatise" printed have disappeared.

By the autumn of 1636, Williams and a handful of his followers had spent nearly a year in exile, enduring "the miserie of a winter's banishment among the barbarians," those tribes that lived outside the shaky boundaries of European control. Williams and his followers walked southeast from Salem, camping out in the smoky longhouses, accepting Indian hospitality, until they reached the bank of the Seekonk River, where the crude housing constructed there was surely little better than the native houses they had shared.

Here Williams found himself and the others in a precarious position between those who had banished him and those on whom he depended for survival.[6]

Informed some weeks later that this land was also within the Massachusetts Bay Colony domain, Williams was directed downriver to the Eastern Shore, where a curious group of natives gathered to greet the long dugout canoe he had borrowed for the short journey. It was, he wrote years later, "a shaggy world of primeval forests, red men, and freedom."

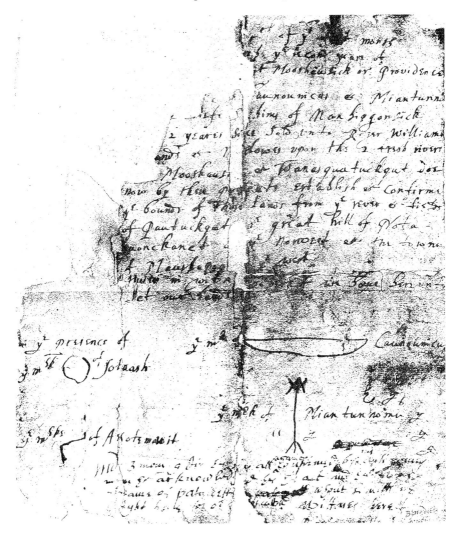

The original deed signed by Canonicus and Miantonomo with Roger Williams for the purchase of Providence. *Courtesy of the Providence City Archives and the State of Rhode Island.*

Once led to what would become Providence Plantations, Williams and his group flourished in remarkable time, establishing a trading post in Cocumscussoc near Wickford and a community in Providence at the meeting of the Moshassuck and Woonasquatucket Rivers, which brought trade with natives from Seekonk, Rehoboth and beyond. Williams became friends with Canonicus, the sachem who had been among those who greeted him ashore, as well as his nephew, Miantonomo, another leader whose later

stance against European encroachment would leave a legacy as a precursor of the Wampanoag Philip (Metacom) in native resistance.

Seven years after stepping ashore onto Narragansett lands, Williams was en route to England to obtain the charter for the lands had had acquired with others from the Narragansett. He took the weeks of ocean voyage to compose a remarkable book on the language and culture he had shared in the past seven years. Ostensibly a guide for missionaries "to spread civility and Christianity; for one candle will light ten thousand," his pamphlet *A Key into the Language of America* was unique in its compilation of the Algonquian language, far exceeding any contribution before, and notable as well for Williams's "briefe Observations of the Customs, Manners and Worships Etc. of the aforesaid Natives, in Peace and Warre, in Life and Death."

Less than a decade after his "banishment among the barbarians," Williams wrote of the natives, "I have acknowledged amongst them an heart of sensible kindnesses, and have reaped kindness against from many, seven years after, when my selfe had forgotten."

In his inimitable style, Williams scoffed at those Europeans who thought the natives uncivilized: "The sociablenesse of the nature of man appears in the wildest of them, who love societie, families, cohabitation, and consociation of houses and townes together…There are no beggars amongst them, no fatherless children unprovided for…their affections, especially to their children are very strong."

This sociableness extended to an equal contribution to the subsistence of the tribe as a whole:

> *When a field is to be broken up, they have a very loving sociable speedy way to dispatch it: All the neighbors men and Women forty, fifty, a hundred &c, joyne and come in to help freely.*
>
> *With friendly joining they breake up their fields, build their forts, hunt the Woods, stop and kill fish in the Rivers, it being true with them as in all the World in the Affaires of Earth or Heaven.*

Williams found an intelligent and curious people who had grasped a clear understanding of what many Europeans saw as a vast and frightening wilderness. "It is a mercy," he wrote, "that for a hire a man shall never want

guides who will carry provisions, and such as hire them over Rivers and Brookes, and find out often times hunting-houses, or other lodgings at night."

By his account, the natives' knowledge went far beyond a familiarity with the forest: "By occasion of their frequent lying in the fields and Woods, they much observe the Starres, and their very children can give Names to many of them, and observe their Motion."[7]

Roger Williams was most moved by their generosity and provided numerous examples of this throughout *A Key*. Most telling were his accounts of their compassion. "It is a strange truth," he wrote, "that a man shall generally finde more free entertainment and refreshing amongst these Barbarians, then amongst thousands that call themselves Christians." In the lines of a cryptic poem, Williams also recalled his months in exile: "In wildernesse, in great distresse / These Ravens have fed me."

Additionally, there was also the description of a yearly ceremony of plenty, which was likely similar to what the Pilgrims experienced with their Wampanoag neighbors:

> *Their chiefest Idoll of all for sport and game, is (if their land be at peace) toward Harvest when they set up a long house called Qunnekamuck... sometimes a hundred, sometimes two hundred foot long upon a plaine... where many thousands, men and women meet, where he that goes in danceth in the sight of all the rest; and is prepared with money, coats, small breeches, knifes, or what he is able to reach to, and gives these things away to the poore.*[8]

By virtue of his own honest and fair dealings, Williams gained the trust of the Narragansett. Soon, though, there arose misgivings about and distrust of other settlers who had wandered into the domain of Providence Plantations.

Chapter 2
Conflicts Arise

While Roger Williams, John Smythe, Samuel Gorton and others benefited from the ability to negotiate for purchases of land and leases of other lands, the arrival of this first European settlement in Narragansett country also presaged the coming conflagration into which they would be drawn: the first European-waged war on American soil.

Colonial tensions with the Narragansett, Wampanoag, Pequot and smaller tribes had increased during the 1630s and 1640s with misunderstandings over treaties, a heightened competition fueled by the English and Dutch over trade and the continuing influx of European hunters, which threatened the native economies, swelling in a slow-rising tide that sometimes spilled into desperation and acts of violence.

The murders of a Pequot sachem and the trader Captain Stone on the Connecticut River in 1634 raised the alarm in Boston, which sent a report of the crime to Stone's home colony of Virginia.[9] There seems to have been little response from the colony, but the following year a party of Pequot arrived in Boston, agreeing to hand over Stone's killers and pay a substantial sum of wampum and fur in damages. The historian James Truslow Adams indicates that there were some tensions between the Pequot nation and the Narragansett at this time, as well as troubles with the Dutch to the west of their lands, and so the Pequot had incentive for maintaining good relations with the English colonists.

Two years later, tensions surfaced again with the news of the infamous murder of John Oldham on Block Island. The Narragansett were

implicated in the murder and the kidnaping of two boys in Oldham's boat. Despite Canonicus vehemently protesting their innocence, and the sachem Miantonomo securing the children's release, in August 1636 the Massachusetts authorities sent militia to the island, where, failing to procure a confession from the natives, they burned their wigwams, staved their canoes, killed their dogs and destroyed the corn they had gathered for winter storage.

John Endicott next led his militia to the Pequot harbor on the Connecticut River, where they killed two natives and then made their way to the village and demanded payment, along with hostages, and the names of Oldham's killers. When the Pequot failed to meet his demands, their villages were also razed and their stores destroyed. This escapade of destruction by Endicott was borne of the Massachusetts authorities suddenly embarking on "a course of blundering stupidity and criminal folly."[10]

In this first "military action" pursued by the Massachusetts Bay authorities, they sent an inexperienced leader and one hundred volunteers from villages around Boston—people who had little compulsion to display any civility or "rules" of war, as they might have applied to a European conflict. For the natives, it was a harbinger of things to come.

In the aftermath of this incident, the Pequot immediately made peace with the Narragansett and urged a unified war against the English. Facing the prospect of so disastrous a conflict, the Massachusetts authorities reached out to Roger Williams, who set out "all alone in a poore canow, and…cut through a stormie wind with great seas, every minute in hazard of life, to the sachem's house."

Williams stayed for three days, finding that a delegation from the Pequot had already arrived. He was not intimidated, however, and stayed on despite "the smelle of English blood on their hands"; on the basis of his arguments and his friendships with Canonicus and Miantonomo, he won the confidence of the Narragansett sachems and bade them to ally with the English. In the fall of 1636, an embassy of Narragansett led by Miantonomo signed a treaty with the English that included a bond against the Pequot.

Most early historians have termed the beginning of such conflict as "inevitable" given the rising tensions and hostilities between native communities and the colonists. More recently, Patricia Rubertone in her volume *Grave Undertakings* muses whether Canonicus and Miantonomo might

have missed an opportunity to change history. By this time, though, there were also troubles with neighboring tribes, and the "inevitable" changes that often come with one culture interacting with another were already making themselves known.

Canonicus at the time of the Pequot War was an elderly sachem. An English party accompanying Williams to the sachem's house during the Oldham incident found the Narragansett leader reclined on his bed yet fully "alert and sharp of minde" in his questioning of the English for their version of events. This very incident may have been an indication of his weakening control, as some accounts indicated that the murder had been sanctioned by lesser, "rogue" sachems of the tribe. Certainly he was aware of the mounting political divisions within the Narragansett and likely saw an alliance with the English as a way to stave off catastrophe.

In the months after Endicott's raids, towns in both Massachusetts and Connecticut lived in dread of Indian retaliation. Three men were killed in Saybrook. Another murder occurred on Six-Mile Island when an unfortunate trader came across a roving band of Pequot, and nine men were later killed in a raid on Wethersfield, with two young girls taken captive.

On May 1, 1637, the Connecticut General Court declared war on the Pequot nation. In the early hours of May 26, a ninety-man militia led by the experienced captain John Mason and John Underhill, bolstered by a handful of Mohegan warriors, set out for Narragansett Bay. Mason then took additional reinforcements of several hundred Narragansett, who led the militia on a daylong march "until an hour after dark," where they camped close by the Misstick fort. Accounts differ as to the extent of Narragansett involvement in the battle. James Truslow Adams said that the English set out "[a]bout one o'clock…but were deserted by all the Indians, Narragansett's and Mohegan's alike, before reaching the fort."

Other historians intimate that the tribe stood far back from the English, who had surrounded the wigwams, and stared in horror at the ensuing carnage. By all accounts, once the firing began, Mason, fearing a costly battle, set fire to the wigwams; the English merely had to shoot any native who attempted to escape the flames.

In his memoirs, the captain claimed that six or seven hundred were "burned alive," and as testament we have John Underhill's grisly recording of "cries of the poor savages whilst they did roast alive." He also recorded that while the

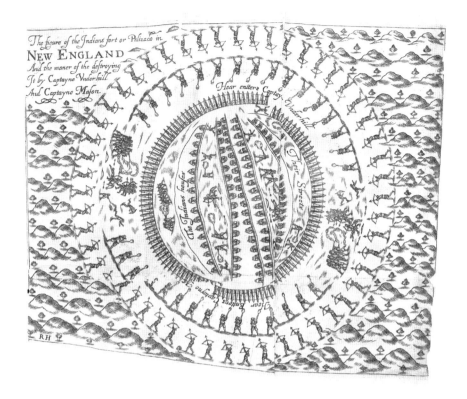

A drawing by John Underhill of the Pequot fort under assault. *Courtesy of the John Carter Brown Library at Brown University.*

natives admired the English style of fighting, "they cried mach it mach it,—that is' it is naught, it is naught because it is too furious and slays too many men."

The Narragansett were displeased with Mason's tactics. They had, in conference before joining the alliance, understood that women and children would be not be harmed in any conflict.[11] Mason's surprise attack left the entire community vulnerable and succeeded in striking a fierce blow against the Pequot nation. Sassacus, the tribe's sachem, was in a neighboring community at the time of the attack on Misstick. He quickly gathered seventy warriors and fled into Mohawk territory.

In swampland just east of the border with Dutch colonies, a band of nearly three hundred Pequot made a last stand. Under fire for more than two hours, nearly two hundred women, children and old men surrendered, leaving the remaining eighty or more warriors to fight to the death.

For their alliance with the English, the Narragansett had been promised rights to Pequot hunting grounds and a share of the wampum captured as well as prisoners of war, who were gradually sent out among the conquerors as slaves. Despite these promises, the Narragansett found that the English were delaying payments and any other goods made on their promise. Accusations were made of the Narragansett letting Pequot prisoners escape, and the unfulfilled English guarantees were sent back and forth to negotiating parties for more than a year.

As Patricia Rubertone pointed out, "For the Narragansett and other Native groups, the massacre at Mystic exposed the English as untrustworthy and ruthless, and only heightened any resentment they harbored against them."[12]

In September, Miantonomo suffered further indignity when he was induced to sign a treaty with the Mohegan and English in which he gave up all rights to hunting on former Pequot lands and agreed to pay an annual tribute for the handful of Pequot slaves they had acquired.

Chapter 3
Miantonomo's Legacy

In the aftermath of the Pequot War, the Narragansett saw the Massachusetts authorities become ever more embroiled in native affairs. The acquisition of land that had once belonged to the Pequot stirred renewed interest in the Narragansett territory. As some native sachems sold ever more land, and others became wary of the colonists' demand for land and resources, tensions naturally escalated. As historian Douglas Leach wrote:

> During these years, friction of various sorts between English and Indians was almost constant, a not surprising fact in view of the close proximity, and the divergent interest of the two peoples. On both sides there were cases of trespass, assault, theft, even murder, all of which served as a continual irritant. The Indians moreover, felt a gnawing concern over the mounting indications that their own culture and way of life were being slowly but surely undermined by the white man.[13]

None felt this as much as the Narragansett. The English had deferred on agreements and placed new regulations on them. To the west of their lands, the Mohegan, whose territory lay to the north and east of Lyme, Connecticut, had signed treaties with the Dutch. The Wampanoag, who still owned much of Massachusetts, had also signed their "league of peace" with the English, though relations proved to be strained and uneasy over the years. This was also a troubled time among the neighboring tribes. Miantonomo had brought divisions within the Narragansett by his friendship

View of Narragansett Bay from *Shawomet*, at *Quinimiquet* (Conimicut), a point of land named for Sachem Canonicus's granddaughter. *Photo by author.*

with Samuel Gorton, an Englishman of consummate independence and a constant thorn in the side of the Massachusetts authorities. Miantonomo had sanctioned the sale of land to Gorton along the Pawtuxet River and had been taken to court by Ponham of Warwick Cove and Soconoco of Pawtuxet, two of his own lesser sachems, who questioned his authority to sell the property. Gorton was arrested soon after with nine of his followers. After Gorton and his followers were released, Miantonomo sold the "Gortonoges" a large tract of land, extending from the bay in Warwick to present-day Coventry. This friendship between the young sachem and the freethinker was witnessed with displeasure by Massachusetts authorities, and tensions were exacerbated by an escalating feud between Miantonomo and Uncas, sachem of the Mohegan.[14]

From a report written by Massachusetts Bay governor John Winthrop, we read that in 1643 the English learned from many "strong and concurrent Indian testimonies" that Miantonomo was "traveling through all the plantations of the neighboring Indians, and by promises & gifts, labouring to make himself their universall Sagamore or Governor, persuading & engaging them, at once to cut off the whole body of the English in these parts."[15]

Summoned to Hartford and confronted with these accusations, Miantonomo reportedly "threatened to cut off any Indian's head that should lay such a charge upon him to his face."

However, Miantonomo had journeyed through the waters of Long Island Sound in the fall of 1642 to delay, if not avert, the Montauk from signing yet another treaty. He asked them as brethren to join with the Narragansett and others in stemming the encroaching English tide:

> [Our Fathers] *had plenty of deer and skins, our plains were full of deer, as also our woods, of turkies, and our coves full of fish and fowle. But these English have gotten our land, they with scythes cut down the grass, and with axes fell the trees; their cows and horses eat the grass, and their hogs spoil our clam banks, and we shall all be starved.*[16]

Having seen the brutal force with which the English could expel the Native Americans, Miantonomo pled that they do what was necessary to free their people from the same fate: "[F]or wee are all the Sachems from East to west, both Mouquakues and Mowhauks Joyning with us, and we are all resolved to fall upon them all, at one apoynted day."[17]

From Winthrop's report, in the spring of 1643 a Pequot Indian, purportedly aiming to take the life of Uncas, fled to the Narragansett and boasted that he had killed the sachem. When the Narragansett learned that Uncas was still alive, the Pequot confessed that Uncas had "cut through his owne arm with a flint, and hired him to say he had shot and killed him."

Miantonomo was summoned to Boston, bringing the Pequot with him. The English desired to send the native back to Uncas, but Miantonomo "earnestly desired he might not be taken out of his hands, promising that he would send him safe to Uncas to be examined & punished." Instead, within a day or two, Miantonomo had "stopped the Pequot's mouth by cutting off his head" and "told the Governor in discontent, that he would come no more to Boston." Following this incident, several more attempts were made on Uncas's life by "poysen and by sorcery."

Upon his return, Miantonomo learned of a skirmish between his subordinate Sequassen and Uncas and complained to the Connecticut authorities, whose response was that "[t]he English had no hand in it." His missive to Governor Winthrop met with similar reserve.

Gathering a band of warriors, Miantonomo marched on Uncas near the outskirts of what is now Norwich. Uncas purportedly challenged Miantonomo to settle the dispute between them, but the Narragansett refused, and in the ensuing battle Uncas overtook and captured Miantonomo, reportedly encumbered in his flight by a heavy coat of mail given to him by his friend, Gorton.

Uncas took the opportunity to strengthen his alliance with the English. Knowing their official neutrality in the affair, he presented Miantonomo to the Massachusetts authorities, who—after a trial in which the Narragansett sachem willingly placed himself into English custody and their court—released him to Uncas, instructing him that he should be taken "[i]nto the next part of his own government, and there put him to death, provided that some discreet and faithful person of the English accompany them and see the execution, for our more full satisfaction."[18]

The Massachusetts Bay authorities sent a handful of men as "protection" for Uncas from Narragansett retaliation and then sent him marching. The Mohegan led Miantonomo to a clearing just into the border of their lands, where the group executed the Narragansett sachem. Reportedly, it was Uncas's own brother who slew Miantonomo with a hatchet blow to the skull.

The Narragansett were shocked by Miantonomo's death and were naturally outraged by the manner in which the English had sided with Uncas, a sachem whose "nature was selfish, jealous, tyrannical" and whose ambition was "grasping and unrelieved by any single trait of magnanimity."

Uncas's alliance with the English might have been understood on a political level by the tribe, but the Massachusetts authorities' support of Uncas could

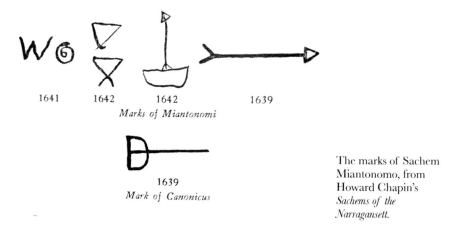

1641 1642 1642 1639

Marks of Miantonomi

1639

Mark of Canonicus

The marks of Sachem Miantonomo, from Howard Chapin's *Sachems of the Narragansett.*

only serve to further the interests of gaining more of the Narragansett's now coveted land.

The threat of war now loomed large between the Mohegan and the Narragansett. The Narragansett sachems refused to comply with a summons from Massachusetts, distrusting the English promise of safe passage.[19] But in an effort, perhaps, to allay further interference in the affair, Canonicus and Pessacus delivered a letter to the Massachusetts Bay General Court regarding the promised compliance with their rules if they treated them with a respect equal to that shown to their former enemies. The tribe requested that a "constable" be sent to live among them "so that if any small thing of difference should fall betwixt us, only the sending of a messenger, may bring it right again."[20] The English delayed responding through the summer and finally sent a delegation to the tribe in September 1644 to "truly heare their grievances"

The Narragansett told the Massachusetts delegation that they had "payed a ransom of wampum such parcels of other goods to a great value" to spare the captured sachem's life. They failed to prove to the satisfaction of the delegation that any ransom had been accepted by the Mohegan. They came only to an agreement that "[h]ostility should cease until planting time."[21]

By February, however, the Narragansett had sent messengers to Boston to forward their demand for 160 fathoms of wampum or another meeting within six weeks—or else war would begin. The colonists accused the Narragansett of invading Uncas's land, unsettling Hartford and New Haven once again. These colonies, in turn, had asked Massachusetts for assistance in their defense.

Soon after, the Mohegan captain who had taken Miantonomo prisoner was "dangerously and treacherously wounded in the night as he slept in his wigwam; and other hostile acts on both parts attempted."[22]

When the Massachusetts authorities again attempted to mediate, the Narragansett refused to parley. A second attempt resulted in a meeting in the presence of Pessacus, the brother of Miantonomo who had assumed his duties as sachem. It was a hostile affair.

According to Winthrop:

They were resolved to have no peace without Uncas' head, it matters not who began the warre, they were resolved to continue it; the English should withdraw their garrison from Uncas, or they would take it as a breach of former covenants, & would procur as many Mohauks as the English should affront them with;

*that they would lay the English cattle on heaps as high as their houses: that no
English man shoud step out of doors to pisse, but he should be killed.*[23]

The English had underestimated the depth of the Narragansett's anger.
Returning from England too late to save his friend, Roger Williams wrote to
John Winthrop that "there is a spirit of desperation fallen upon them."

Williams pleaded with the Massachusetts authorities for leniency toward
the Narragansett, but he also wrote resignedly to the governor that the tribe
was "resolved to revenge the death of their prince…or to perish with him"[24]

That spring, Pessacus led a large army of warriors into Mohegan country. The
Narragansett drove the Mohegan west until they retreated to their fortification
at Shantok above the Thames River. The fort proved too formidable for a
pitched battle, and the Narragansett encamped nearby and lay siege. Uncas,
however, was able to get word to the English at Saybrook, and though they did
not send troops, the Connecticut authorities did send supplies to the fort from
the river. When the Narragansett discovered the provisions being taken inside
by English troops, they became discouraged and eventually returned home.[25]

On the advice of Samuel Gorton, who had been permitted after a year
in exile to return with his followers to the bay, the Narragansett petitioned
Charles I with An Act of Submission, "freely, voluntarily, and most humbly…
submit, subject, and give over ourselves, peoples, lands, rights, inheritances
and possessions…upon condition of His Majesties royal protection."

When an English delegation visited the Narragansett again, it was
supported by an array of troops and presented the tribe with a treaty
that made them culpable for the actions taken against the Mohegan with
a payment of two thousand fathom of wampum to the English. The
Narragansett were to renounce any claim to the former Pequot lands, as
well as pay a yearly tribute for the remaining Pequot within the tribe.

Overwhelmed by the display of force and embittered by their recent
failure to oust their enemy and retreat from Uncas's lands, the Narragansett
signed the English treaty. It was an act that Pessacus would say later "hath
bene the constant grief of my spririt."

Indeed, in the years that followed, his authority would diminish in favor
of Ninigret, a sachem who soon set the Narragansett on a path of passive
resistance, as year after year they refused to pay the tribute and year after
year troops were sent to collect the payments.

Chapter 4
The Reign of Ninigret and the Rise of Metacom

Ninigret was a vocal spokesman for the tribe in the same way that Miantonomo had been. Through years of summons, he steadfastly remained resistant to English rules of conduct. Besides his delay of payments, he refused to recognize the bay authorities as a subject of King Charles. When answering the charge of plotting with the Dutch against the English in 1653, Ninigret refused to lower the loaded musket he had in his hands, a reminder of the mistrust the Narragansett held for the English a decade after the death of Miantonomo. Forced to relinquish the tribe's Pequot prisoners for nonpayment in 1654, Ninigret relented but refused to end the skirmishes he had begun with Long Island Mohawk after they had killed a Narragansett sachem: "Such a prince and two such captives loss theire lives and theire blood not to be revenged to this he must acte in a right way."[26]

This stance of active resistance, however, began to have a costly price within the tribe. Some sachems initially refused to contribute any payments to the English, leaving Ninigret and Pessacus in the position of forcing tribute from their unwilling subjects.[27] He also borrowed heavily to make payments when demanded by force, and in this way the English-led Atherton Company began collecting what had been Narragansett land for centuries.

A majority of the Nipmuck abandoned the tribe in 1667 to place themselves under English protection by agreeing to retire to what became known as a "praying village," under the leadership of missionary John Eliot. The Narragansett attempted to bring them back under their authority through a legal complaint, but once again the English ruled against the

tribe. There were periodic episodes of vandalism to white settlers' houses and barns near Narragansett land, as well as the occasional individual Indian act of violence against white settlers. In 1669, one witness recorded a particularly hostile meeting with a Connecticut delegation sent to issue Ninigret an ultimatum: "I…saw Ninicraft's men, almost one hundred of them, have clubs in their hands, and the Inglish men layed their hands upon their swords Ready to draw."[28]

After this confrontation, an uneasy lull existed throughout New England, but a sea change was coming. The older generation of sachems who had brokered peace with the English were slowly fading. Canonicus was elderly and mostly ineffectual in tempering the bloodlust of his young warriors under the aging Ninigret and Pessacus. Massasoit of the Wampanoag had died peacefully in 1662, but his sons, anointed with the English names of Alexander (Wamsutta) and Philip (Metacom), were of a different mind. While Wamsutta professed to retain the policies of his father, rumors began to reach Boston that he was resisting the Christianization of natives within his territory and that he also sought a new alliance with the Narragansett.

Summoned to appear before the general court in Plymouth, Wamsutta declined to attend, and this resulted in an armed force led by Majors William Bradford and Josiah Winslow riding out toward Bridgewater and confronting the sachem at his hunting lodge on the shore of Monponsit Pond. Some accounts had Wamsutta led back by force to Plymouth at gunpoint,[29] but in a letter from John Cotton to Increase Mather, the account by Bradford indicated that Wamsutta had returned with the men of his own volition.

Having settled his affairs, Wamsutta was en route to Wampanoag lands when he caught a fever while lodging at the home of Winslow in Marshfield. He requested to be returned home at once but died before reaching his lodge. His death naturally raised suspicion among the already mistrustful Wampanoag, who became convinced that the English had poisoned their leader.

It was against this dramatic backdrop that Metacom assumed the position of sachem from his brother. Almost immediately summoned to Plymouth, he renewed the league of friendship, with the Wampanoag to be treated as English subjects in return for Metacom's promise not to alienate his lands without consent of the court.

Within five years, he was summoned again on charges of disloyalty— more specifically, dealing with the French and Dutch, always suspect in plots

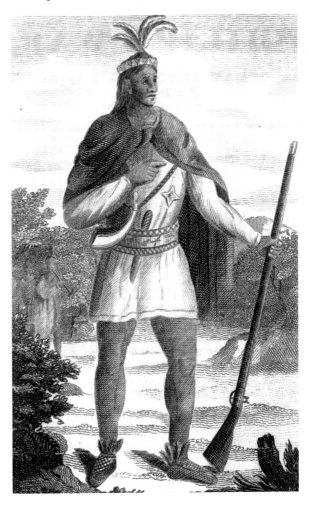

Artist's rendering of
Metacom or "King Philip,"
from Samuel Drake's 1823
edition of *Church's Diary of
King Philip's War. Courtesy of
the John Carter Brown Library
at Brown University.*

against the English colonies. Metacom replied that this must have been some scheme of Ninigret's. His story that the purchase of muskets and powder were for the defense of his people against a plot by the Narragansett fell on suspicious ears, as the tribes had been long known to be on friendly terms.

Both sachems were then summoned to a hearing with a pair of commissioners at Rehoboth, where Ninigret restated his claim that Metacom was dealing with Dutch authorities. The Wampanoag were forced to surrender their arms for a brief time while the accusations were investigated, and no truth to them being found, the court returned the weapons gathered with the stipulation that Metacom pay for the expedition that had been sent to escort him to Plymouth.

Metacom was again summoned in 1671 and, after some delay, met with the Plymouth authorities in the Taunton church on April 12 amid an air of tension and mistrust:

> [B]*oth parties were armed: the Indians with their faces and bodies painted in the savage manner, with their long bows and quivers of arrows at their backs, and here and there a gun in the hands of those best skilled in the use of them; the English in the Cromwellian habit, slouched hats with broad brims, bandoliers, cuirasses, long swords and unwieldy guns.*

The authorities questioned Metacom once again about his rumored cache of weaponry and designs against the English. Metacom repeated his claim that his preparations were in defense of threats from the Narragansett. After a long hearing, the authorities succeeded in obtaining a slight "confession" from Metacom in answer to the accusations that the Wampanoag had hidden "enemies" amid the tribe, that they had been late in payments of tribute, and late in previous orders to relinquish weapons to authorities. The sachem relented to a new plan of disarmament, agreeing to turn in weapons at appointed places over the course of several months.

The weapons failed to materialize, however. By September, only seventy had been handed in, and the sachem was summoned again, under threat of force, to appear on September 13. Metacom traveled to Boston and appealed to the Massachusetts Bay authorities. While denying his appeal to be treated as a subject of the colony, Massachusetts authorities did propose that the dispute be referred to commissioners from Connecticut and Massachusetts and levied this criticism toward the government in Plymouth:

> *We do not understand how far he hath subjected himself to you, but the treatment you have given him and proceedings toward him do not render him such a subject as that if there be not a present answering to summons there should presently be a proceeding to hostilities: and the sword once drawn and dipped in blood may make him as independent upon you as you are upon him.*[30]

Despite this missive, the Wampanoag were induced to sign another treaty on September 29, agreeing to pay another tribute in value of £100, to sell

View of Narragansett Bay from the shore of *Montop* (Mount Hope). *Photo by author.*

lands only with consent, to refrain from engaging in war with any Indians and to confer with authorities at Plymouth should any differences arise.

Following this last agreement, an uneasy peace existed between neighboring tribes in New England and the colonists. But if this was seen as an indication of Metacom's meekness and submission to English rule, those who were lulled into such suspicions were sorely mistaken. As James Truslow Adams wrote: "That he nursed his revenge, and carried on negotiations with other tribes for a simultaneous rising against the whites over a considerable territory, would seem to be well established."[31]

Chapter 5
Metacom's War

No doubt Metacom had designs on recovering land for his people and throwing off the yoke of the English colonies and that "at the time he was engaged in preparing for a general rising...had the sympathy of some of the other New England tribes."[32]

The murder of the Christian Indian John Sassamon[33] has long been seen as the event that propelled the Wampanoag into conflict, but as Adams discerned, "Once started, the example of a native rising would prove contagious; and there is little evidence to prove that the widespread movements along the seaboard were connected by threads that centered in the hut of the Wampanoag."

There is no written record of the messages "sent far and wide along the trails of New England" and no written accounts of the "parleys...held at council fires all over the lands of the Algonquians."[34]

The arrest of three Wampanoag of the murder, their subsequent trial and their hanging was in any Native American eyes a sight that might occur before any of their people—a further vindication of earlier mistrust of the colonies. The three unfortunate Wampanoag were hanged on June 8, convicted by the testimony of a "friendly" Indian named Pawtukson who claimed to have witnessed the murder from a ridge overlooking the frozen pond.

The evidence at the crime was slight and the testimony of Pawtukson questionable, given the testimony of the accused that the same witness had "gambled away his coat and, on it's being returned and payment demanded...had, in order to escape the debt accused them of the murder."

But to the English at this juncture, it was as though Metacom himself was on trial. For the weeks of the trial, settlers lived in fear of reprisals, and there were reports of houses broken into, cattle slaughtered and barns set ablaze from throughout the region.

On that June day, two Wampanoag were quickly hanged, but the third, having fallen without being strangled on the gallows, was reprieved long enough to obtain a confession and then shot. Authorities may have been satisfied that justice had prevailed, but to the common New Englander, the whole affair had exposed them to a wave of terror and anticipation of native atrocities.

One early historian attempted to capture the temper of the times: "Men saw portents that foreboded evil days. Comets in the form of blazing arrows shot athwart the skies, and the northern lights took on strange and awful shapes. Many heard the thunder of hoofs of invisible horsemen, and bullets fired from no earthly weapons whistled through the air."[35]

Just three days after the hanging, Lieutenant John Brown of Swansea reported to the Massachusetts authorities that witnesses had seen Wampanoag women ferried across the bay to seek protection among the Narragansett. This would seem to indicate an agreement between Metacom and Pessacus amid some prewar planning on their parts. Even more alarming were the rumors Brown had heard of warriors journeying from Pocasset, Cowesit and Narragansett communities to join Metacom's forces. In addition, the main route between Swansea and Taunton, a main avenue of escape for besieged residents, was already being closely watched by the Wampanoag.

Massachusetts authorities immediately sent messages to Metacom and Weetamoo, the squaw sachem of the Pocasset, but the advent of war seemed to be foregone conclusion.

This was confirmed in mid-June when Benjamin Church of Little Compton attended a dance with his neighboring Sakonnet, hoping to persuade them against Metacom's designs. While there, the husband of Weetamoo, Peter Nunnuit, informed him that Metacom was determined to wage war and that neighboring Indians were indeed swarming the Wampanoag encampment to join the fight. Church hurried to Boston and arrived on the morning of the sixteenth to give Governor Winslow the dire news.

Within a few days, the violence had erupted, first with a band of warriors marauding settlements on the neck of land adjacent to the peninsula on

which their encampment lay. Finding the farms on the neck already abandoned by frightened residents, they looted and plundered the houses, setting fire to two dwellings while what residents remained fled toward town to sound the alarm.

Through the months that followed the initial conflagration in Swansea, the Narragansett maintained political neutrality in the war. In that same month of June, a delegation—consisting of Captain Edward Hutchinson, Seth Perry and William Powers—had summarily been dispatched to meet with the Narragansett sachems. These three were first sent to Providence to enlist the services of Roger Williams, the old peacekeeper, to persuade the Narragansett from supporting Metacom.

Williams tried to arrange a meeting at Smith's Trading Post in Wickford, but the sachems would not meet at the house[36] and instead made the delegation travel some fifteen miles on the old Pequot trail to Great Pond,[37] where they sat down to parley. In attendance were Ninigret and his nephew, Canonchet, as well as Pessacus, and the "old queen" Quaiapen, widow of Mriksah, the eldest son of the late Canonicus.

The Narragansett were informed by the English delegation that Massachusetts was determined to put down the rebellion, even if it took thousands of troops to do so. It would be foolhardy for the tribe to become involved in the conflict.

Ninigret appeared to appease the English with his support, taking much the same line as he had done earlier when informing on Metacom's activities. Pessacus, however, while professing that his heart sorrowed, could not promise that he was able to control the younger warriors or persuade lesser sachems to withhold support for Metacom. While pledging to remain neutral in the dispute between Plymouth and the Wampanoag, a mistrustful Williams wrote to John Winthrop that he feared that the Narragansett had spoken "words of falsehood and treachery." This seems to indicate a change in Williams's relations with the Narragansett.

Though in past years, even in the wake of Miantonomo's attempted uprising, Williams had asked for leniency toward the tribe from the authorities, he was now writing of their supposed treachery. Perhaps having lost Miantonomo, the elderly Massasoit had taken the two most influential allies from him and the English. Throughout Williams's long career as a minister, pamphleteer, governor and statesman, he had "frequently acted

as a translator and mediator in negotiations with Colonial Authorities and also furnished the latter with intelligence on Native affairs by serving as the eyes and ears of Narragansett Bay."[38] While the elders of the Narragansett clan still held Williams in respect, there had been signs for some time that he was losing his influence with them, especially after the Pequot War and Miantonomo's death. Less than a year after the meeting at Great Pond, with the war fully engaged, Williams, while fleeing Providence, crossed a band of Narragansett warriors about to descend on the settlement. When asked why they waged war, John Wall-Maker (known as Stonewall John) told him: "You have driven us out of our own countrie and then persued us to our great miserie, and your own, and we are forced to live upon you."

In that summer of 1675, those who had kept the peace within Rhode Island were dwindling down to a precious few. Ninigret was an ancient sachem by the time of the war, and Pessacus, though he did not know it, would not live another two years (killed by the Mohawks beyond the Piscataqua River in the winter of 1677). Williams himself was still a vigorous old man, but he must have seen that the younger generation of Narragansett was caught up in Metacom's brazenness and that the bleakness of a future without freedom spurred many a young warrior with dreams of glory, if not death, on the battlefield.

It is difficult to know how many Narragansett left their peaceful encampment for Metacom's battles, but it is known that Pessacus, Ponham and Canonchet harbored many refugees during the months of war. Ninigret

Stone steps leading to "Philip's seat" at *Montop. Photo by author.*

seemed to tow the English line, although he certainly knew what Pessacus was doing behind the backs of the English, and only infrequently turned in warriors the Narragansett had captured as their treaty attested.

There were outward signs that tensions were escalating as well. In late June, a group of Narragansett suddenly encamped near Warwick, causing alarm. Williams was again enlisted and, in early July, set out with Captain Hutchinson and Captain John Mosley, accompanied by "rangers," into Narragansett country to meet with the sachems.

It was at first a fruitless mission. They found the Narragansett compound abandoned, with crops still growing in the fields. Though message after message was sent along the trails, the delegation could not find a party to meet with them. Williams wrote that he feared that things would soon come to "blows and bloodshed."

When Canonicus, the elderly sachem, could not be found, the Massachusetts agents, joined by those from Connecticut, negotiated a treaty with a few unimportant individuals, who were forced to obligate the tribe to join the English in making aggressive war on Metacom.[39]

Other sources, from George Ellis and John Morris to Howard Chapin and Douglas Leach, have all related the same description of "unimportant individuals," though no one seems certain of their identities. Chapin points out that these individuals were induced to sign "as attorneys" for Canonicus, Ninigret, Canonchet, Ponham and Quaiapen, although these Indians had no such power of attorney.[40]

It was clear that the Narragansett had no intention of any agreement with the English. Their mistrust of Uncas was clearly borne of his dealings with the English and was always a bone of contention in negotiations. As late as the meeting at Great Pond, punishment for the sachem's role in the death of Miantonomo was a topic raised by the Narragansett.

By October, the Massachusetts authority had summoned Canonchet to Boston and induced him to agree to the terms of the treaty signed by his "attorneys" in July. Two weeks later, Plymouth declared war on the Narragansett on the basis of the tribe "relieving and securing Wampanoag women and children and wounded men" and failing to deliver them as promised. A decree by the colonies was quickly raised with the cheerful proclamation that if those who signed up "played the man" and drove the Narragansett from their country, the army would then receive allotments of land with their pay.

The Narragansett had indeed been "relieving and securing" the refugees of the war since its beginning. And while Ninigret brought unwanted stragglers to the English, the sachems in South County were preparing a refuge for the hundreds of Wampanoag who had sought asylum. The refuge was a fort built "on an island of 4–5 acres in the middle of a large swamp."[41]

Despite winter coming on, the fort had yet to be completed and so was only partially protected by "pallisadoes stuck upright in a hedge of about a rod in thickness." Two fallen trees formed natural bridges that were the only entrances, and the principal one was guarded by a blockhouse. The stores, harvest and accumulated wealth had been brought inside the fort.[42]

On December 14, Plymouth forces led by Governor Winslow attacked the village of the squaw sachem Matantuk in the area of Wickford, routing the villagers and burning more than 150 wigwams. The English killed seven and took nine captives. They marched on to "other sundry skirmishes" before approaching the Great Swamp. While encamped at Smith's landing, the contingent—which now included a newly arrived company led by Major William Bradford and Captain Gorham—learned that the Narragansett had taken revenge on the evening of the fifteenth at the large stone house of Jirah Bull, which sat in the clearing atop Tower Hill. The English had chosen the house as the rendezvous point with the Connecticut troops, and the Narragansett, noticing the flickering of fires, set on the house swiftly, killing fifteen and leaving two wounded to tell the tale to the English before setting the great house ablaze.

The assembled army waited for yet another force to arrive from Connecticut. Three days later, the combined forces joined at Pettaquamscutt that night in the snow, in sight of the grim, black ruins of the garrison.[43] The night brought new snowfall and kept the men awake: "We lay, one thousand, in the open field that long night."[44] Early the next morning, the armies regrouped and began the march toward the Great Swamp.

Accounts of this terrible battle in the ice, snow, frozen brush and fallen trees are all from the pens, typewriters and computers of white historians, and while all contain the rudimentary facts (and fictions), as well as the sequence of events and loss of life, they fall short. They can only summarize a day of horror, death and atrocity in a few paragraphs of prose.[45]

I have returned in my reading to eyewitness accounts, not those necessarily written years after events, but in letters and reports written in the days and

weeks that followed. These, to my eyes, still bear the vibrancy of the words written on the page and still recall the smell of gunpowder and smoke, the cries of the wounded and the blood on the snow of the frozen swampland.

Joseph Dudley, an army chaplain wrote that

> *a tedious march in the snow, without intermission, brought us about two o'clock in the afternoon to the entrance of the swamp, by the help of Indian Peter, who dealt faithfully with us; our men, with great courage entered the swamp about twenty rods; within the cedar swamp we found some hundreds of wigwams, forted in with a breastwork and flankered, and many small blockhouses up and down, round about.*

Another eyewitness recounted how "our whole army…went out to seek the enemy, whom we found (there then happening a great fall of snow) securing themselves in a dismal swamp, so hard of access that there was but one way for entrance."

Dudley again related how the Narragansett

> *entertained us with a fierce fight, and many thousand shot, for about an hour, when our men valiantly scaled the fort, beat them thence, and from the blockhouses. In which action we lost Capt. Johnson, Capt. Danforth, and Capt Gardiner, and their lieutenants disabled. Capt. Marshall also slain; Capt. Seely, Capt. Mason, disabled, and many other officers, insomuch that, by a fresh assault and recruit powder from their store, the Indians fell on again, recarried, and beat us out of, the fort.*

Benjamin Church wrote later that "the wigwams were musket proof, being all lined with baskets and tubs of grain and other provisions."

After about three hours of intense fighting, Dudley again recounted in his letter that

> *by the great resolution of the General and Major, we reinforced, and very hardly entered the fort again, and fired the wigwams, with many living and dead persons in them, great piles of meat and heaps of corn, the ground not permitting burial of their store, were consumed; the number of their dead, we generally suppose the enemy lost at least two hundred men.*

The men left the fort to find "a broad and bloody track where the enemy had fled with their wounded men." The English were also reeling from the fight. The chaplain wrote that

> [a]*fter our wounds were dressed, we drew up for a march, not able to abide the field in the storm. And weary…with our dead and wounded, only the General, Ministers, and some other persons of the guard, going to head a small swamp, lost our way, and returned again to the evening quarters, a wonder we were not prey to them.*

Captain Oliver, in his report some days later, confirmed that "[o]ne signal mercy that night, not to be forgotten, viz. That when we drew off, with so many dead and wounded, they did not persue us, which the young men would have done, but the sachems would not consent; they had but ten pounds of powder left."

Oliver reported that in the days following the battle "[w]e have killed now and then 1 since, and burnt 200 wigwams more; we killed 9 last Tuesday."

After the battle, Canonchet reputedly fled the Great Swamp to Misnock Swamp in present-day Coventry and then into Metacom's territory. A series of peace talks throughout December and early into 1676 faltered, and by March the Narragansett were fully involved in the war. Some historians have Canonchet leading a force through the Connecticut Valley in March 1676, attributing raids at Lancaster, Medfield and Groton, as well as the burning of the abandoned Simsbury to Canonchet's band of Narragansett, or combined forces. Tribal history, however, places the sachem at the heart of a battle that left its own legacy on Rhode Island lore.

On March 25, Captain Michael Pierce and a company of Plymouth volunteers skirmished with a small band of Narragansett, having marched the Old Seacunck Road to Rehoboth (then part of East Providence), where they were joined by other men and continued to Pawtucket Falls.

The falls had been a traditional fishing ground for centuries, providing alewives, shad and salmon for generations of Narragansett. Reports of a "large gathering" were relayed by witnesses who were likely viewing a yearly ritual of spring fishing for the tribe. Pierce and his men encountered the group north of the falls, and while a light skirmish broke out, the Narragansett soon fled, and Pierce marched his men back, without loss, to the garrison in Old Rehoboth.

Recent historians have speculated that this skirmish may, in fact, have been devised by the Narragansett to either assess the strength of Pierce's unit or to lure them into an ambush. In any case, Pierce set out again the following day and marched along the Seekonk River, likely passing Roger Williams's old settlement as they headed north toward Pawtucket. Local lore has it that Pierce's men were watched by the Narragansett from Dexter Ridge, as they made their way forward through the "obscure woody place" to a ford at the Blackstone River. Here, Pierce and his men spotted several Narragansett who appeared to be fleeing the advancing force. Following them into the woods, Pierce and his volunteers suddenly found themselves surrounded by "about 500 Indians, who, in very good order, furiously attacked them." He managed to cross to the western side of the Blackstone and engage the Narragansett in a fierce battle but, within a short time, was met with a reinforcement of "about 400 Indians" that his volunteers kept at bay for a little more than two hours, forming a ring and fighting the natives back to back until "55 of his English and 10 of their Indian friends were slain upon the place."

By all accounts, this battle took place in the "North Woods" of Providence, now Central Falls. Those who escaped this battle were to meet a grisly end. Making their way into an area known as Camp Swamp, local legend has nine making a brave stand before a large rock, where they perished. More recent historians have conjectured that the nine were captured and marched to their place of execution, where their scalped and broken bodies were found several weeks later. The place where they were found has been known since that day as Nine Men's Misery, and a plaque noting such was affixed to a fourteen-foot stone monument in Cumberland by the Rhode Island Historical Society (RIHS) in 1928.

On March 26, Canonchet led his warriors to a site above the Great Cove overlooking Providence. It was here, reportedly, where Roger Williams came to meet them, hoping to defer an attack on his settlement, and here where the words of Stonewall John fell on his aging ears—he knew that Providence was lost.

The Narragansett destroyed fifty-four houses, including Williams's on Towne Street (which they also plundered), the building that served as a town hall, and the early records of the settlement were thrown into the millpond. Only two of the city's houses were spared, including the Roger Mowry

House, an early inn and important meetinghouse that was to survive another two hundred years before it was destroyed by fire.

If Canonchet felt any redemption at the destruction of English property, it was to be short-lived. On April 3, an expedition of "some forty-seven soldiers" led by Captain James Denison of Connecticut captured a squaw near Pawtucket, who informed them that the sachem's camp was nearby. Pressing onward through the woods, the party soon spied two sentries, who quickly fled, and then came upon a small group of natives, who also fled in all directions. Among them was Canonchet, who threw off a blanket used to disguise a silver-trimmed coat that would have immediately identified him and ran to the Blackstone River. Slipping in the water, rendering his gun useless, the sachem was forced to surrender.

Denison marched the captured Canonchet to Stonington, where he was reputedly offered his life in exchange for an end to hostilities. He deferred, preferring death with the comment that "he liked it well, that he should dye before his Heart was soft, or had spoken anything unworthy of himself." The man who was to be called "the last great sachem of the Narragansett" was executed and his head sent to Hartford as tribute.

It was said that the death of Canonchet had a debilitating psychological effect on Metacom and his followers. They were pursued until the fateful day of August 12, when the Wampanoag leader met his own end at the hands of an Indian named Alderman, a "disenchanted Pocasset" who fired upon Metacom after an English soldier's musket ball had narrowly missed the sachem.

Following the end of the war, Ninigret was recognized as the chief sachem of the Narragansett, and he signed another treaty with the victorious English even as his own people drifted, seemingly aimlessly, through destroyed woodlands, fearful of reprisals from settlers and English militia determined to eradicate the Indians from their newly claimed territories. Many remaining warriors were killed, and hundreds of captured women and children were sent as slaves to the West Indies from Plymouth. Some historians estimate that by the time of a new treaty signed in 1682—and the assimilation of the remaining Narragansett into the eastern Niantic tribe—the population of the Narragansett hovered only at about five hundred. These settled into an area near Charlestown. After the death of Ninigret in 1679, the role of sachem was given to his eldest daughter, Weunquesh, and upon her passing in 1686, her half-brother Ninigret II acquired the role of leadership.

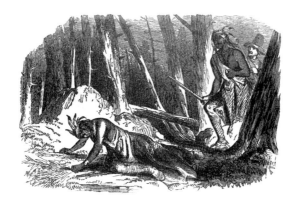

Nineteenth-century illustration of *The Death of Metacom*, reprinted in the *Diary of King Philip's War* (Little Compton Historical Society, 1975).

In the years that followed, the tribe would continue to struggle for existence. The colonial government and encroaching settlers would continue to take parcels and attempt to eradicate the memory of those sacred places through the use of farming and grazing, as well as building white communities on what had once been Narragansett land.

In October 1713, the young missionary Experience Mayhew traveled into Connecticut to meet with Mohegan tribesmen on their reservation. Finding that the Indians had "so universally gone out hunting" and so his planned meeting could not occur, Mayhew left a letter in lieu of a sermon and sidestepped into Rhode Island to search for any remnants of the once famed Narragansett tribe. The now elderly Ninigret II denied him the privilege of speaking to his people and, through a pair of interpreters, told him that those natives now imbedded with the English as either servants or slaves no longer listened to him—and would listen to a missionary even less. If the English religion was so good, he asked Mayhew, why didn't black-robed ministers like himself "make the English good in the first place, for he said many of them were still bad."

Not wishing long to "play the martyr," Mayhew spurred his horse and headed back into the woods, keeping close to the Pequot guides he had hired, lest an ambush be planned after this decidedly unfriendly encounter. The young missionary no doubt sought nothing more urgently than the comfort of the small Cape Ann community of "praying Indians" he'd left behind—so far removed from the smoky campgrounds, the common wigwams and the insolence that remained in these "stubborn descendants" of Miantonomo.

Part II

THE GHOSTING OF A PEOPLE

Chapter 6
A Way of Life
Forever Changed

After this defeat, the Rhode Island Indians had no independent life. They seemed to have lost the fine characteristics which had endeared them to Roger Williams and become treacherous, thriftless, and low. After a number of years when they had suffered from poverty and disease, the remaining Indians deeded their lands to the Colony and asked to be taken care of. They were given a reservation in South County and lived quietly there, making their own laws and living their own lives. But their strength had gone and they passed away, until now it would be impossible for us to find anywhere in the state a full blooded Indian of the Narragansett tribe.[46]
—*Alice Collins Gleeson,* Colonial Rhode Island *(1926)*

By the beginning of the eighteenth century, the Narragansett, along with other indigenous tribes, had endured a century of assault on their populations, their lands and their culture. European settlements in the region had brought an incredible influx of settlers, traders, trappers, fishermen, pirates and opportunists of all kinds to New England shores, with the result that disease, conflicts, poverty and war had all disrupted in little more than one hundred years what had been unchanged for so long.

The Narragansett were spared the large losses that other tribes endured from the most recent plagues of smallpox and other diseases, although by this time they had lived through several generations as witness to the "sad spectacle" in those wasted villages where "skulls and bones were found in many places, still lying above ground, where their houses had been."[47]

While many early settlements had been established in abandoned coastal native communities, as the European population grew the surrounding areas

were quickly deforested, not only to clear needed land but also to obtain building materials, wood for fences and firewood for the hearth. The need for this resource consumed acres of New England forest, and the fields of stumps and the piles of charcoal fires amid the devastation must have sorely affected the native sensibility to the woodlands.

The Narragansett had their own tradition of clearing land for the growing of crops, especially corn but also pole beans and squashes. They were well established as the greatest agricultural nation of the tribes on the eastern seaboard. Early European travelers made note of the "park-like" forests that were carefully maintained. The sight of wasted land and smoky cairns of charcoal must have filled them with dread. By 1640, the Narragansett had been subjected to a treaty that forbade that they "kindle or cause to be kindled any fiers upon or Lands" under English jurisdiction, upon punishment "tried by our law."[48]

Among the other propositions within said treaty were agreements that "no Indian shall take any Cannew from the English neyther from their Boatside or shoreside & the like not to be done to them" and that "upon their trading and bargaining having agreed they shall not revoke the sd bargaine or take their goods away by force, & that they shall not be Ideling about nor resort to or howses, but for trade message or in their Journeys."[49]

The colony made it law in 1641 to levy a steep fine on any citizens selling a firearm to the neighboring Indians:

It is ordered that if any Person or persons shall, sell, give deliver, or in any ways convey, any Powlder, shott, Gunn, Pistoll, sword, or any other Engine of warr, to the Indians that are or may prove offensive to this State or to any member thereof…shall forfet the sum of 40s & for the second offense offending in the same kind shall forfeit 5li half to our Sovr Lord the King & half to him that will sue for it.[50]

Rhode Island records show a few early examples of the colony's enforcement of the law. During the quarterly session of the Aquidneck Court on December 3, 1643, we find the case of William Richardson, who upon his "[i]nditmt of selling a peec to the Indian was injoined to bring in againe the sd peec by the last day of June ensuing."[51]

In another case held in October 1646, the court sued Ralph Earle "for forty shillings upo the breach of the Law in furnishing an Indian with a

Gun he being convicted by wm Balsto & others...The Court orders the peece that is in Mr. Easton's hands wch was taken from the Indian provd to belong to Thos Layton and to be dd to the Recod who is to keep itt til the 40s be pd."[52]

These legal salvos from the English began a scant five years after Roger Williams had stepped ashore seeking exile within the Narragansett lands.

In response to this abrasive authority, native sachems, though unfamiliar with English perceptions of boundaries, tried to stem the encroachment by selling tracts of land and often retiring their tribe as far as they could from these "English borders."

Trappers and fishermen, naturally, threatened the natives' own needs and economies, as well as brought a cultural change within tribal communities.

Early on, individuals acquired consent to fish, hunt and trap on native lands. Their extended stays in native communities introduced American Indians to new technology, better tools and other implements but also brought the ravages of unknown diseases and the first interracial relations, as trappers took native wives or integrated themselves within one tribe or another.

Traders who came and went brought the baubles and beads, the trinkets that elderly leaders soon grew to disdain. They also brought alcohol, introducing another form of devastation to native communities. Growth accelerated as white populations continued to grow and settlers expanded across the region. Between 1660 and 1710, more than two hundred new townships were established in New England.[53]

With existence tied to their environment (unlike the European manner of changing the environment to suit their existence), the Narragansett and other tribes were pushed into a situation of desperation.

But these assaults also resulted in an unprecedented confederacy among former enemies as their world closed in around them. As we have seen, European settlements were often suspicious of native activities and often ignorant of true relations within tribes. Native leaders sometimes used this to their advantage in their dealings with the English, the Dutch and the French.

There is evidence that during the prelude to King Philip's War, movements along the eastern seaboard of native warriors suggested that many tribes, perhaps recalling the late Miantonomo's urging, were in some form of preparation for a major uprising. As it happened, a few colonists,

including Governor Winthrop in Connecticut and Roger Williams of Rhode Island, prevented a complete alliance among the Algonquin tribes—the Narragansett among them, as well as the Wampanoag who went to war against the Massachusetts Bay authorities. This likely saved the colonies for the English, but the resulting months of skirmishes and desperate battles, as well as the outright razing of villages on both sides, extended from as far as York, New York, to Newport and Providence, Rhode Island, and Springfield and Deerfield, Massachusetts. The war most certainly involved Nipmuck, Narragansett, Abenaki, Tarrantine and Wampanoag warriors.

Following the war, Rhode Island refused to send those captured Narragansett accused of treason to face trial in the Massachusetts Bay but was willing to convict and execute them in its colony. Those Native Americans not in hiding or "traveling" the eastern forests assimilated into other tribes. The remaining Narragansett aligned with those Niantic who had sought shelter during the war under Ninigret's rule, whose people adopted the nobler name for themselves. As such, the colonies recognized Ninigret as the sachem and then his daughter, Weunquesh, upon the elder's passing.

The brief summary of Narragansett history posted as the prelude to this composition is typical of the view that nineteenth- and even twentieth-century scholars have taken, but for a few who have broken the ground for this modern era of reevaluation. The devastating effects of King Philip's War became the final chapter in many a narrative concerning the Narragansett. As late as 1975, a young scholar's dissertation on the period published in the prestigious *New England Quarterly* included the hasty assessment that after the war "only a degenerate remnant attempted to preserve a traditional life under the sachem of the Niantic tribe."[54]

Such a statement does not do justice to the efforts of the squaw sachem to gather her scattered people. The Narragansett had under agreement allowed the Niantic to take shelter in the "rough and swampy country between Westerly and Kingston." And it was here where Weunquesh established an integrated colony. She was also a shrewd negotiator and, not having satisfaction with the Rhode Island court in 1689, petitioned the Narragansett commissioners of the king to see her claims justified.

Upon her death, and in a lavish ceremony that was to be a prelude of his lifestyle, Ninigret II assumed the role of sachem.

Chapter 7
A Divided and Dispirited Nation

To be sure, Ninigret II inherited a depopulated and devastated people. The smoky camp of wigwams that the missionary Mayhew encountered were but a fragment of the free Narragansett. Others had left to live among other tribes that held relations or lived in piecemeal camps along the sandy boarders of Narragansett that were unwanted or as yet unnoticed by the colonists. The era of the lone "wandering Indian" began in the aftermath of the conflict, and the resulting skirmishes and alcohol-related incidents led authorities to pressure Indians throughout the region to gather their remaining people onto reservations (tracts of land the colonists would grudgingly give that held a handful of sacred places, a burial ground or place of worship).

Such was the pressure placed on the sachem that in 1709 he and his council willingly agreed to give Providence Plantations all remaining Narragansett land in exchange for a such a reservation in Charlestown that included the area where the tribes had lived since the gathering with the Niantic.

In the years that followed, settlers and land speculators continued to persuade individual Narragansett to sell parcels or continued the tradition of employing debt as a means of obtaining land. Narragansett leaders petitioned the state for assistance in 1713, and by 1717 the colony of Providence Plantations had placed Narragansett lands in "trust"—such was the infighting among the tribe over lands that were sold to accommodate the sachem's lifestyle.

Ninigret II was an unpredictable sachem and a violent man. He had first married a Pequot squaw with whom he had two children who died very

An iconic nineteenth-century engraving from the slave trade. Native American slavery was often overlooked by abolitionists, and such slaves were valued less than their African counterparts.

young. He married a second squaw, named "Mary," the daughter of the "black sachem" Wamsitta, who bore him a son who also died in childhood. A third marriage occurred with a Mohegan squaw and then a fourth to another Pequot squaw named Pashkhanas. By this time, Ninigret II had become so degenerate that one night after a "Royal Party" of drinking liquor, the sachem woke and slashed his wife's cheek with a knife in a fit of misguided jealousy. He did, however, father two sons with Pashkhanas, named George and Charles, who lived into adulthood, the latter of whom was elected sachem after his father's death about 1722.

In his early history of New England, Joseph A. Conforti points out that Ninigret II's long history of selling native lands and his arrogance and sense of entitlement as sachem wreaked a new kind of havoc on

the stability of a tribe that still numbered well over a thousand members. The Ninigret family, the "King-Sachems" of the Narragansett, gained legal control over thousands of acres of tribal land. They used it not on behalf of fellow reservation Natives, but to finance a lavish Anglicized way of life that emulated the colonial gentry and aspired to European royalty.[55]

Court records throughout the first half of eighteenth-century Providence Plantations portrayed the ongoing generational conflict among the "royals" for control of the rapidly diminishing native lands, as well as disputes as to the title of sachem among the children and grandchildren of Ninigret II. By mid-century, nearly all of the land given as a reservation was gone. Under sanction of the colony in 1746, more land was sold to pay off the family's mounting debts. These disputes, more than any other factor, painted a negative portrait of the tribe among colonial leaders and were to be used to diminish the once proud history of the Narragansett and set in motion the dismantling of remaining tribal lands and authority in the next century.

Chapter 8
The Advent of Slavery

Let us step back for a moment to examine the social upheaval that began after the colonial victory in King Philip's War. As mentioned previously, a large number of Narragansett were captured and shipped as slaves to the West Indies. This had been the intent of at least a few prominent colonists, as demonstrated by the letter of Emanuel Downing to John Winthrop in 1645: "If upon a just warre (with the Narragansett) the Lord should deliver them into our hands, wee might easily have men and women and children enough to exchange for Moores, which will be more gaynefull pilladge for us than we conceive."

It was partly for this reason that colonists believed that another uprising might easily occur should natives remain as slaves near their former lands.[56] Because of this concern, a significant number of Narragansett were sent to Block Island, where the town council could oversee their regulation. The colony sold the remaining Indians into slavery, scattering the captives to remote rural farms or selling them to individuals outside Providence Plantations. The price for each individual varied but averaged at around thirty-three shillings in silver,[57] though records indicate that payment was also accepted in "fatte sheep" and "bushells of Indian corn."

One such Narragansett, first listed as "Tobee" in a certificate of Colonel Johnson's hand, was obtained in 1676, lived under the same roof as the slave trader as his servant and, after twelve years, was given his freedom. He later purchased a tract of land from the Naugatuck as Toby Johnson and obtained

the deed as a free Indian in 1713. When he died in 1734, he deeded his land to the three sons of his beloved colonel, as well as another white man.

The strain of forced integration continued to take its toll. Itinerant American Indians had long wandered through the region, taking odd jobs and sometimes working for a stretch of time before moving on. Those who settled mostly came into debt, as did other free blacks and poor white settlers, and the colony sanctioned slavery or servitude through court punishments of a term of years based on the crimes perpetrated or the amount of debt that was owed.

In 1675, the Providence Plantations Assembly declared that "[n]oe Indian in this Colony be a slave, but only to pay their debts or for their bringing up, or custody they have received or to peforme covenant as if they had their countrymen not in warr."[58]

Among the Narragansett who resisted capture and enslavement in the Indies, there were few who did not fall under the reasons the colony deemed appropriate for enslavement. From the time of the enactment of this law, records in South Kingston contain no references to Indians whatever beyond those listed as a "servant" or "indentured servants."[59]

Boston papers from the period occasionally mentioned a "runaway slave" from Block Island, but also from other communities within Providence Plantations. Slaves were indeed distributed within communities on the mainland. While Indian slaves, like black slaves, were often given their masters' names and "Christianized" in this fashion, notices from the *Providence Gazette* throughout the eighteenth century identified runaways by their origins, as well as remarkable features and characteristics. Thus we find in a notice from Mary Greene of Warwick for "an Indian Man, named Buck, 23 years of age…has a Scar just above his Forehead, and another on one of his Feet, two of his upper Teeth are out, has a Roman Nose, and wears long black Hair; he plays tolerably on the violin."[60]

These and other records exist of slaves serving for periods of time in Providence, Warwick and, most notably, in South Kingston, where a census in 1730 showed the community to hold 223 Narragansett slaves. A generation later, there were still 193 Narragansett slaves listed in town registers.[61]

Amid the rolling hills of Narragansett Country were long-established farms and estates of families who became known as the "Narragansett planters." The estates planted tobacco and hemp in their early years in an effort to cultivate a finer, more elite crop than the smaller farms, which grew the bulk

Portrait of Washington on a Narragansett pacer during a visit to Williamsburg. General Washington favored the breed for their swiftness and surefootedness in the New England landscape. He is said to have owned a pair at Mount Vernon after the war.

of produce for the Newport and Providence markets. By this period, however, the planters had come to find the breeding and trading of the Narragansett pacer[62] a lucrative endeavor.

A sleek horse, the pacer was adept in the New England landscape and was a valuable steed for a messenger or swift traveler. Paul Revere and George Washington were later said to favor the breed. Washington owned two pacers on his Virginia estate, one so spirited that it became known as the only horse that had ever thrown the equestrian general.

The pacer became even more valuable during the fever of horse racing that broke out over Britain, as well as Rhode Island, the only colony whose strict adherence to separation of church and state allowed such "frivolous sport" to flourish. The estates of the planters employed free Indians for labor, as well as the indentured blacks and native Narragansett.

The Hazard, Robinson and Stanton families were reputed at one time to have owned many slaves. More recent historians have placed the number at about forty per family, but a memoir of P. Hazard's recalls his grandfather "relieved" to pare the household servants down to seventy. There were also productive dairy farms neighboring these estates, and these farms sometimes rivaled the estates in the breeding of the famed Rhode Island dairy cow, valued in other colonies and often exported to the West Indies. These dairy farms and cattle breeders "employed" both black and Indian servants, as well as smaller farms that grew produce for market in Newport.

Chapter 9
Masters and Mustees

There were also individual owners of Narragansett slaves. As early as 1647, William Coddington wrote to John Winthrop

> *in the behalfe of naybor Capting Moris, that have lattly lost his Indian mayde-servant, and as we sopose is com into your libertyes...therfor my request is that you be pleased...to macke inquiery for her, and if found, to cause her to be sent home agayne unto her master, or so much wampom as may purches eather an other Indean or blackmor; for Mrtris Morris as agged and weack, and is in great destres for want of a servant.*

In later colonial records, we find that the will of one Benjamin Barton of Warwick in 1720 lists an Indian boy named "Daniell" along with the boy's mother among his valued belongings. In 1738, George Hazard registered "one mustee and two Indian indentured servants." Likewise, Jeremiah Wilson's registry of 1749 lists a "[m]ustee servant named Jacob."

The term "mustee" was one used to represent the offspring of black and American Indian partners who shared the experience of slavery and had intermarried for some time. By the time of these registrars, several generations of children of black and Indian parents had been born. Slave owners referred to mixed blacks as mulattos or as native slaves from a foreign country—identifying a missing "spanish indian" or, by way of definition, a "clear indian." Mustees also appear in the notices from 1762 onward of the *Providence Gazette*, a forerunner of the government's press; there was a general public reduction in the identity of

Portrait of the Newport minister Ezra Stiles, painted by Samuel King, 1770–71. *Courtesy of the Redwood Library, Newport, Rhode Island.*

the Narragansett and other tribes during the next century. These mustee generations of the Narragansett often grew up in slavery. If they were not born in a master's house and added to the property, they were dropped on the doorsteps of estates, farmhouses or even meetinghouses by free Narragansett women who were often impoverished and sometimes shamed by their relatives for their interracial unions. Perhaps the most poignant telling of the desperation of the people during this period is the infanticide that occurred at what came to be known as Crying Rocks.

Writing in 1761, Reverend Ezra Stiles, who was then pastor of the Second Congregational Church in Newport, wrote of Narragansett women taking to the woods to give birth to "illegitimate" children near the site "where they killed so many infants, & their bones lay about so thick, that they go by the name of the Bastard Rocks."

Narragansett tradition recounts the practice of infanticide, but in the context of a newborn with a crippling disability or an infant who was sickly and without hope of survival. Reverend Harold Mars acknowledged in an interview about two hundred years after Stiles's account that "when a child was born deformed or crippled in any manner, it was the plan and practice of the Indian people, with proper ceremony, to put that child to death because obviously the child would be handicapped…and this thing having gone on for many years, why there was a build up of little skeletons."[63]

The Ghosting of a People

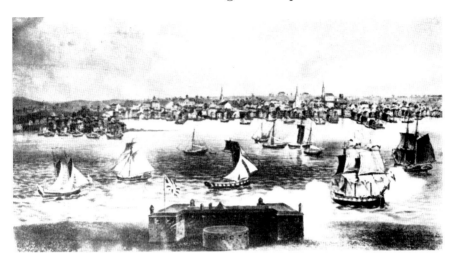

An engraving of Newport, circa 1740. *Courtesy of the Rhode Island Historical Society.*

At the same time, prominent medicine woman Ella Wilcox Sekatau acknowledged the prejudice that some Narragansett had for children of mixed blood, considering them "imperfect"—contributing to the "loss of Indianness" in the eyes of the colonists and even of other tribes, for such prejudice among American Indians of the region was not uncommon.

The Narragansett were familiar with black races as early as the seventeenth century, for Williams wrote that their language described "a coale blacke man" as "Suckautacone."

This word, according to Williams, was used to describe an African, but we have no way of knowing whether the same word applied to other dark-skinned people or if the encounters were with slaves or mariners. Early in the eighteenth century, interracial unions occurred with little notice; Indian tradition had long allowed visitors to marry into tribes if the newcomer agreed to contribute to the welfare of the people and abide by the people's customs. By mid-eighteenth century, however, many native women married or absconded with free blacks who worked in the maritime trades or on the estates in Newport or other neighboring farms.

Perhaps most telling are documents that show the state of the tribe during this time. When Reverend Joseph Fish arrived in Charlestown in 1765, he met with a faction of the tribe to provide religious instruction and help build a school. In December of that year, he was given a "list of the Family's Belonging there unto

and number of children Thats fit for Instruction." Among those listed within this faction of seventy-four Christian Indians were twenty-two widows.[64]

A Narragansett perspective was given in the account of William J. Brown, the indentured son of such a marriage, as well as the grandson of a Narragansett woman who had "purchased her husband from the white people in order to change her mode of living." Brown wrote that

> [t]*he Indian women observing the colored men working for their wives, and living after the manner of white people in comfortable homes, felt anxious to change their position in life; not being able to carry out their designs in any other way, resorted to making purchases...The treatment that Indian women received from the husbands they had purchased was so satisfactory that others were encouraged to follow their example, notwithstanding every effort was made to prevent such union.*[65]

These events presented a perceived threat to the Narragansett and other tribes, and a backlash came in a wave of racially related violence among Indian men within the affected tribes of New England. The schoolmaster James Deake wrote to his supervisor in December 1765 that the Narragansett tribal council had voted to disown "a considerable Number of mixtures as mulatoes and mustees" in addition to "sundry families of Indians which properly belongs to other tribes."[66]

It appears that this prejudice was not extended to Europeans, who had long intermarried or fathered children with Indian women. Gary Nash, among others, writes of the long-standing practice of traders and trappers, even European settlers, intermarrying and taking Indian wives along with them for the practical skills they offered, as well as companionship in an unfamiliar landscape. There were also many instances over generations of settlers being drawn in by the freedom that the remaining Indians offered, intermingling with the tribes and sleeping with their women, though the colonial authorities certainly looked on such affairs with distaste.

In another letter from 1640, William Coddington on Aquidneck Island wrote to John Winthrop to warn him of

> *a lude felowe, one Theo. Saverye, whom I heare is now in durance with yow...Lately I wos informed that at a place called Puncataset, upon*

the mayne land, wher he kept the last summer, & wos much frequent in following, &c. he hath a child by an Indean womon, which is a boy, & not black-haired lick the Indean children, but yellow haired as the English, & the womon being laitley delivered, doth say English man got it, & some of them name him, & when he ranne away from us, he would at Titecute lyne with Knowe Gods mother, which doth speake of it in detestation, & that those that professe them selves to be Christian should be more barbarous & wyld than Indeans.[67]

While Plymouth Colony authorities persecuted natives for infanticide in a "proportionately greater number than white women," such was not the case in Rhode Island, although there is a 1729 case on record from a deposition for the court given by an elderly Narragansett woman named in court papers as "Indian Hannah" against a squaw named Sarah Pharoah, testifying that the young Sarah came to her "and told her yt She was not Well, and was Much out of Order and Desired…[that Hannah] Get Some Roots" for her to take. The elderly woman testified that "[s]he thought she was with Child, and if So the Taking of Roots would kill…the Child, and She [Sarah] must be hanged for it."[68]

Little is known about "Indian Hannah" except that she had once been "one of the old women who procured abortions"[69] among the Narragansett. Given the Christian name by which she was sworn in the deposition, and her newly formed belief that such practice constituted a criminal act, we can assume that she had come under the influence of religious teachings and was likely among those "praying Indians" who had converted with the first wave of English missionaries into Rhode Island.

Perhaps, as Patricia Rubertone has suggested, by the period in which Ezra Stiles was writing, Narragansett women faced "allowing a baby who carried the stigma of mixed blood to grow up in a world where its life would be defined by worthlessness and degeneracy in the eyes of European Americans? Or permitting such a child to become the possible object of mounting frustration and uncontrolled rage among close relatives and members of their natal communities?"[70]

Between 1750 and 1800, towns within the colony officially "indentured" ninety-eight Narragansett children, one as young as twenty-one months old and another boy, named John, of "4 years 4 months & 6 days old." As Ruth

Wallis Herndon and Ella Wilcox Sekatau wrote in their study of this era, "This was a common practice in eighteenth-century New England; town 'fathers' acting in the stead of natural parents, placed poor and/or orphaned children of all races in more prosperous households under contracts that obligated the children to live with and work for their masters until adulthood."[71]

Whatever caused some Narragansett women to consider this "necessary evil," it was apparently during this period of integration and shared slavery that the traditional practice was adapted to include unwanted children of mixed race.

This natural integration of blacks and Indians, and the tragic consequences, is a story that has only been lightly touched on in the written histories and perhaps among the oral histories of the tribe as well.

Of those Narragansett who served time as slaves, we know that they were valued less than the black slaves on the planter's estate, and there is little evidence that they were given any task above that of an unskilled laborer. This meant that Narragansett slaves were suppressed in ways beyond the black slaves on these estates. To fully understand what this meant in the day-to-day living of the Indian slaves, we must examine a little of the shared life they inhabited.

A typical Narragansett farm of the period, from Bacon's *Narragansett Bay.*

As slaves on the planter's estate, they would have been segregated from the master's family during meals, eating with black slaves in the kitchen, while the family ate in the parlor. The food sent back for slaves to eat in the kitchen was often little more than the leftovers from the family table. As slaves drew rank according to responsibilities, the Narragansett, confined to the basest of all jobs, would certainly have endured a tradition of ridicule and poverty.

Some historians have ventured that slaves, like those in New England who often slept in the large farmhouses and outbuildings, enjoyed a familial closeness with their masters, and often this argument has used the aforementioned example of Toby and the colonel to show how this easily occurred. More recently, Robert K. Fitts makes the point that rather than fostering closer relations, such arrangements restricted the ability of northern slaves to keep alive their traditional culture and beliefs:

> [D]uring daylight slaves were supervised as they worked—yet southern slaves, living in quarters, had the nighttime to talk freely amongst themselves, by living within the main house—this was difficult for most Narragansett slaves…to practice traditions and exchange information to help them resist their master's domination.[72]

While the Narragansett slaves toiled as farm laborers, shoveling the stalls, driving the cattle to pasture or cleaning the main house, black slaves were given all manner of skilled jobs to perform. They shrewdly used this time to reconnect with relations or visit other slaves they were acquainted with in Wickford, Newport or at neighboring estates in Narragansett when they were sent to deliver messages, produce or livestock.

Other slaves confessed to "retreating to the woods to pray," and certainly Narragansett slaves would have taken any opportunity to keep alive sacred rituals and practices. It is known that as early as 1726, and well into the latter part of the nineteenth century, Narragansett slaves gathered "once a year in June…on Rose Hill in Potters woods to hold a fair."[73] The traditional powwow held in August also continued to be attended by Narragansett slaves, if they were not prohibited by their masters.

The planters tried various means over the years to maintain rigid control over every aspect of their slaves' lives: enjoining the colony to pass laws such as that of one in 1704 that imposed a nine o'clock evening curfew on "any

Negroes or Indians, Freemen or Slaves" and the act in 1708 that aimed to "suppress any person from entertaining of negroes or Indian servants that are not their own, in their houses or unlawfully letting them have strong drink." Masters segregated slaves in church by forcing them to sit separately from other worshipers and also in death by burying them in scarcely marked graves beyond the formal boundaries of the family plot.

Despite these efforts, Narragansett and other slaves found ways to circumvent the authority of their masters. The Narragansett were, in effect, always a gamble to the planters and other masters throughout the colony. There was always the risk of flight and the slave quickly hiding himself within the reservation or with those Narragansett who continued the long tradition of traveling for extended visits with relatives or making pilgrimages to sacred sites.[74]

As the generations of Narragansett slaves merged in the registers of planters with black slaves, planters no longer cared to make the distinction; the identity of a people began to be erased from the records of the colony. By the time of the Rhode Island's adoption of gradual emancipation in 1784, as well as the ban on trading of slaves within the state three years later, most of the estates and farms in Narragansett country already employed a number of former slaves and servants, some of whom chose to remain living on the properties.

Chapter 10
A Laborious and Ingenious People

E mployment of Narragansett Indians by individuals and even towns within the colony had its own long tradition. As early as 1639, a handful of Narragansett were enlisted—by Thomas Hazard, Nicholas Easton and William Brenton—to help clear land on the newly acquired island of "Aquedneck." According to several accounts, the white settlers, having cleared trees, found their work hampered by the "impenetrable low brush" of the swamplands. A group of Narragansett were hired for the sum of "five fathom of wampum peage" and a coat—"the Indians soon after fired the swamp and…it was in time cleared and filled in with gravel and sand, and thus, after much labor, made sufficiently firm for building lots."[75]

Communities also hired Narragansett laborers, as did the town of Warwick in the spring of 1653, paying a group of Narragansett twelve pounds and ten shillings for building stone fences,[76] a novel necessity once the woodland resources were expended. The aforementioned John Wall-Maker, whose Narragansett name was Nawhaum, was better known as Stonewall John by the English. Stonewall John was considered to be a pioneer of this trade, for his skills were well known throughout the colony. Roger Williams knew him from his early days as a servant to Richard Smith and described him as "an ingenius fellow and peasable." Stonewall John was thought to have helped design Queen Anne's fort in Wickford, as well as the stone balustrades that kept the English at bay for some hours during the Great Swamp fight. He was also a blacksmith, "the only; man amongst them that fitted their Guns and Arrowheads"[77]; and reportedly fled from the burning encampment at Great Swamp with his tools.

Before the outbreak of that conflict, early settlers of Rhode Island hired Narragansett men on a regular basis for seasonal work on farms, as well as short-term construction labor; this tradition was reestablished after the war was over. Despite one writer's assessment early in the eighteenth century that the Narragansett were "scattered about where the English will employ them,"[78] free Indians survived with skill and cunning as laborers, allowing them, even with what most considered a marginal existence, to keep the lifestyle of their people and a certain independence and freedom, the likes of which those who had chosen or fallen into indentured servitude could not have enjoyed. By the close of the eighteenth century, another testament was written by missionary Daniel Gookin, who despite having failed to convert the Indians to Christianity showed an undeniable admiration for these "active, laborious, and ingenious people; which is demonstrated in their labors they do for the English of whom more are employed, especially in making stone fences."[79]

Some Narragansett men found "employment" by acting as guides or even mercenaries for the English in their military skirmishes against other Native American or European enemies. Unaccustomed to the "skulking way of war" practiced by the Narragansett and other tribes, European military leaders nonetheless noticed the intrinsic value they had in the wilderness as opposed to the open fields and hillsides of European battles. A Swiss officer in the British forces summed up the difficulties of European soldiers in the unfamiliar terrain:

> *I cannot think it Advisable to employ regulars in the Woods against Savages, as they cannot procure any Intelligence, and are open to Continual Surprises, nor can they Pursue at any distance their Enemy when they have Routed them, and should they have the Misfortune to be Defeated the whole would be destroyed if above one day's March from a Fort.*[80]

Indians were "far more capable than the English," as well as "very terrifying to the enemy" and served as the "indispensable eyes of the colonial forces."

Narragansett men joined military excursions for a number of reasons, most often the simple need for an income in the newly European-dominated colony. Others became Christians and joined to further assimilate themselves into the white man's world. This transformation occurred within

a generation or two, with the resulting irony that in 1709 Benjamin Church, the now elderly commander who had fought the Narragansett at the Great Swamp, was in Newport enlisting a force of two hundred Indians "skilled in handling the whaleboats," which he planned in using for a second attack on Port Royal.[81] Church later successfully lobbied for the Indians who had served under him to receive a tract of land in Tiverton.

In August 1757, after the French attacked Fort William Henry in New York, the Colony of Rhode Island issued "an ACT for raising One Sixth Part of the Militia in this Colony, to proceed immediately to Albany, to join the Forces which have marched to oppose the French near Lake George."

Among those listed on the muster roll to be marched out of the county of Newport was "Josiah…an Indian."[82] The distinction of race being unusual, it is likely it was listed because the man identified himself without a Christian surname.

With the onset of conflicts with Great Britain and the burning of the British patrol ship *Gaspee* when it ran aground on the sandbar from the point that now bears its name, communities throughout Rhode Island mustered militias into service and included Narragansett Indians among the rolls. Narragansett oral history tells us that when war was imminent with the English, word was sent out among the tribes and places where the people had gone, and many were "called back" to enlist in these militias.

The historian Colin G. Calloway made the compelling argument that in addition to the economic reasons for enlisting, the

New England Algonkians, already surrounded, if not submerged, in Anglo-American society may in some cases have seen in the revolution an opportunity to demonstrate their right to equality…When war broke out, most had little desire to go to war against their American neighbors, and many chose to support them against redcoats who often resorted to tactics of coercion to enlist Indian support.[83]

Later generations spoke proudly of their ancestors' involvement in the war and their own perseverance on the land. "My Grandfather in his time stood second in the council for years and years. He was a member, went to the Revolutionary war, and came back and lived and died at home," said Narragansett Joshua Nokes, proudly, to the committee that would eventually strip the tribe of its sovereignty.

The Revolutionary War took a heavy toll on those tribes that participated in both the English and Continental armies. As Calloway noted, "The war sapped the remaining strength of the Connecticut tribes and the Narragansetts." People returned to ravaged reservations, where among survivors "idleness and intemperance increased." Villages were suddenly populated with widows and orphans without any means of support but that which their impoverished neighbors could offer.

As with slaves and "praying Indians," the Christianized names used on the muster rolls often disguised the individual's heritage, and it is difficult to come to an exact number or percentage of Narragansett who enlisted in the war.

Most telling are the desertion notices, which, as with runaway slaves, mention origin and characteristics. And while the numbers of Narragansett deserters were far fewer than the Irish, Scottish and English indentured servants—or the black slaves who had enlisted for freedom and a paycheck—they identify what we must assume would be a low percentage of those who volunteered. In fact, of the thirty-eight "slaves" listed in the Narragansett Historical Register as enlisted in the Continental army, only twenty-year-old William Greene was shown in the desertion notices, leaving the regiment of Captain John Dexter's company of the Ninth Battalion in the early spring of 1777. He, like hundreds

A watercolor showing the diversity of enlisted soldiers during the Revolutionary War, from the diary of Jean Baptiste Antoine de Verger. *Courtesy of the Anne S.K. Brown Military Collection, Brown University Library.*

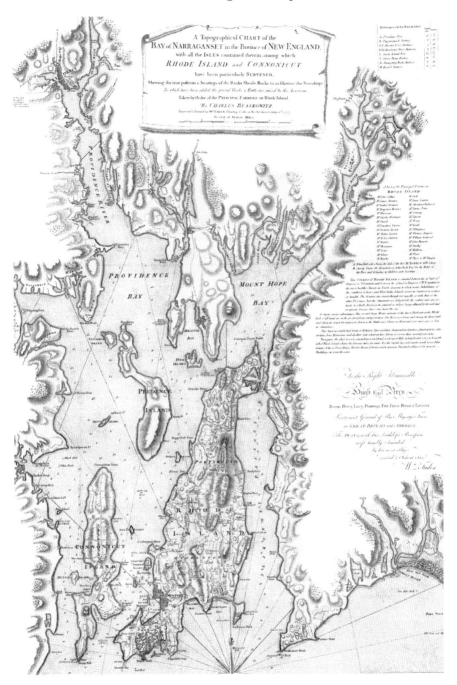

A topographical map of Narragansett Bay, 1777. *Courtesy of the John Carter Brown Library at Brown University.*

of others, deserted after the dismal winter with barely the clothes on his back and then, like many of his compatriots, reenlisted the following year. Of the Narragansett listed, we find the following: On July 5, 1777, the *Providence Gazette* included in its deserted notices "Benjamin Wicket, an Indian, 26 years of age, about 5 feet 10 inches high, long black hair, cut square off at the earlocks" who, in March 1778, "[d]eserted from my company, in Col. Crary's regiment, about the middle of February last, James Allen, a likely, well-set Indian fellow, 22 years of age. 5 feet 5 inches high; he belongs to East Greenwich."

These notices often listed the deserters' home of origin or where they enlisted, implying in legalese that if the "renegade" returned, the town would be responsible for his detainment. Often these notices were quite detailed, as seen in that which appeared of deserters from Colonel Grreene's regiment on May 19, 1781: "James Booney, an Indian (inlisted for South Kingston) born in Westerly, 30 years of age, 5 feet 7 inches high, and is a cooper by trade."

Such a wealth of information often left the Narragansett and other natives little choice but to vanish into the wilderness or take to the sea, a possibility further noted by the authorities. These notices often ended with a stern but hardly enforceable warning: "All masters of vessels are forbid carrying off said deserter, at their peril."

Some Narragansett men intentionally chose a life in maritime service by joining the fishing boats out of New England ports but more often opted to sign on to whaling vessels for "long lays," journeys that could easily last for three to five years, out of ports as far north as Provincetown and Nantucket but also from New Bedford and "a number of outposts on Narragansett Bay."[84] Most recently, a researcher from the Mystic Maritime Museum speculated that Narragansett whalers may more likely have signed on to vessels in New London.

The occupation of whaling, as difficult and arduous as it was, apparently came naturally to many Narragansett. As Elmo Paul Hohman pointed out in his definitive work, *The American Whaleman*, "For an undetermined length of time before the white man came, the Indian tribes living along the southern coast of New England had pursued the whale in canoes from the shore."[85]

According to Hohman, these events of early whaling in Narragansett Bay were somewhat of a rarity but apparently occurred often enough that Indians developed the courage and skills necessary for the occupation, and

Contract for Indian "John Wood" on a whaling voyage. *Courtesy of the Providence Public Library.*

"when the whaling knowledge and dexterity of the Indians were combined with the heavier boats and implements of the colonists, the percentage of captures rose materially."[86]

As with the slaves and soldiers, many a mariner's name was a Christian surname, given or adopted in order to better assimilate into the burgeoning population and become one of many "Freebornes," "Smiths," "Tuckers" and "Woods" looking for work in the southern New England ports. Whalers also became active in the Revolutionary War. In 1775, John Paul Jones, the newly named commander of the sloop *Providence*, met among his crew "a

full-blooded Narragansett from Martha's Vineyard—a whaleman by trade," and some have speculated the model for Melville's "Queequeg" in *Moby-Dick* was none other than a Narragansett whaler named Queequegunent, killed by the British during the war.

It was not unusual in this period for the wives of the whale men to be an indentured domestics in one of the Newport or Narragansett estates while they waited for their husbands to return. Newport employed the largest number of Narragansett females as domestic servants, with Charlestown and South Kingstown following close behind. The largest population of free Narragansett women, according to the 1774 census, comprised the estimated 252 living on the reservation in Charlestown. But there were also Narragansett women, and presumably wives, scattered throughout the colony, from Tiverton and Little Compton to Providence, Barrington and Bristol. Oral history of the tribe speaks to the fact that Narragansett women lived more often among colonial people, moving "more easily between the two worlds."[87] Despite this, these free women of the Narragansett often faced economic uncertainty and the brunt of colonial authorities who remained largely ignorant of Narragansett tradition.

While the months that a whaler's or mariner's voyage took him from his wife were a perfectly aligned occurrence to the Narragansett, the colonial authorities viewed such absences as abandonment. In the latter half of the eighteenth century, local authorities spent an increasing amount of time and legal paper dealing with "transient" residents. If these individuals became in need of assistance, local authorities issued "warn-out" orders, essentially a removal notice for the resident to return to their "hometown," where they would be entitled to town relief. As a recent study of the period pointed out, "Women were the targets of most of the warn-out orders issued to native people."[88] For the wives of mariners and whalers, this meant an adult life of uprooting and resettling from town to town. For the elderly, it was worse.

The councilmen of Jamestown decreed that Mary Pisquish, being "lame and incapable of supporting herself," should be moved to Warwick. Officials there sent her back. She was "transported several times between the homes of the overseers in the towns" until the case was settled.[89] Other elderly native women were "transported" to their hometowns, which often were not the towns of their own family but that of their husband or a place of earlier servitude.

Chapter II
A Faith Borne
Across the Water

It was around this time that the dichotomy of the tribe changed as well. When the last of the Ninigret men, corpulent "King Tom," married "a mulatto woman" named Moll Drummer, he was heavily in debt and drink. The two children his wife bore, like those of his great-grandfather, died before him, although he would only live eight years after his union.

Many of the remaining leaders of the tribe signed a petition to abolish the title of sachem at this time[90] but were persuaded by the remaining members of the Ninigret family to elect Thomas Ninigret's sister, Esther, as squaw sachem.

Our first glimpse of her in the state record is her petition in 1770 to sell more land in order to settle the late Thomas's debts. Her petition was granted. Three years later, the committee of white men that had long overseen tribal affairs agreed to sell the remaining lands but for "the point of Fort neck," which was by this time the remaining legal access the Narragansett had to the bay.

With the establishment of Esther, the spendthrift days of the Ninigret men and the aspiration to "royalty" had finally ended. When she petitioned the court, she did so with her husband, Thomas, beside her, playing the role that she had to play for the Governor Lord Huffington. However, "Queen Esther" had managed tribal affairs with the committee for some time before brother Thomas's death and hoped that her actions in strengthening the tribal council to deal with authorities would benefit the tribe in the future and ensure democracy.

After about seventy years of an enforced monarchy, borne of envy for the wealth of European nations and the stature of "royalty," the Narragansett were to be a nation of council once again. But it was also a tribe fractured by the changes of those years outside the reservation, including the ongoing influence of European culture and Christianity. The excesses of Ninigret II had for some time divided the tribe. With the advent of missionaries and meetings of the Great Awakening, some Narragansett turned away from the sachem and his own adaptation of Anglicanism to the faith offered them by Jesuit and Protestant missionaries and then the "new lights" of the Great Awakening.

As it was with European traders, contact with missionaries and believers came early to the Narragansett. Roger Williams briefly wrote of the native beliefs in his *A Key to the Language of America*, whose first paragraph on the topic begins with a tribute:

> *He that questions whether God made the World, the Indians will teach him. I must acknowledge I have received in my converse with them many Confirmations of those two great points, Heb II 6. Viz.*
> *That God is.*
> *That he is a rewarder of all them that diligently seek him.*
> *They will generally confesse that God made all: but then in speciall, although they deny not that English-mans God made English Men, and the heavens and earth there! Yet their Gods made them and the Heaven and Earth where they dwell.*[91]

Williams also recalled a conversation: "[W]hen I had discoursed about many points of God, of the creation, of the soule, of the danger of it, and the saving of it, he assented, but when I spake of the rising againe of his body, he cryed out, I shall never believe this."[92]

In fact, despite visits from Massachusetts missionaries like Mayhew, William Simmons and others in the first decades of the eighteenth century, the Narragansett clung to their own beliefs and resisted external influences on their faith. Many found the various English faiths practiced in New England to be confusing and the white man's faith or lack of a consistent belief to be a sign of their own spiritual discord.

For many Indians in Rhode Island, the first real exposure to Christianity came with the appointment of Reverend James MacSparren to St. Paul's

Episcopal Church in Narragansett about 1720. The minister actively sought converts among the population of black and Indian slaves who attended his congregation, baptizing fourteen Narragansett of full or mixed blood and marrying one couple in the thirty-seven years of his ministry.[93]

Sachem Charles Ninigret petitioned King George for an Episcopal church to be built on tribal land, though the small wooden church built there, known as the Church of England in Charlestown, never attracted the same number of Indians as MacSparren's congregation. The first man of the cloth to achieve a major conversion among the Narragansett on the reservation was Reverend Joseph Park, a Harvard-educated minister and one of others sent out on an "errand in the wilderness" to convert natives to Christianity.

Park arrived in 1733, and though he preached and, notably, presided over Sachem Charles Ninigret's funeral two years later, he found the Narragansett resistant to his efforts. With the first wave of the Great Awakening, however, and the evident equality among those who attended outdoor meetings, interest was stirred among the native communities. Park found himself integrated into a newly formed community of "new lights," where neighboring preachers traveled to nearby communities during the winter of 1741–42 in what must have seemed a continuous flurry of meetings with "Ministers and Exhorters" preaching "among the English and Indians."

By the spring, Park had many new converts, and the congregation had determined to form a church. This was accomplished by August 1742, with Park ordained by a handful of the "new light" ministers in attendance. Initially, Park's congregation was mostly English, but a shift seems to have occurred during a visit from a party of Indian converts from Stonington.[94] On February 6, Park preached a sermon to the assembled Indians and found

> [t]*he Glory of the* LORD *was manifested more and more. The Enlightened among them had a great Sense of spiritual and eternal Things: A* SPIRIT *of Prayer and Supplication was poured out among them; and a* SPIRIT *of Conviction upon the Enemies of God. I attempted to preach from 2 Cor. 6. 2. but was unable to continue my Discourse by Reason of the Outcry.*[95]

After this meeting, Indian attendance increased until, by February 1744, the church membership consisted of 106 members, with 64 being baptized

Indians; at least 2 members of the congregation were black. Park wrote enthusiastically of the Indian converts that "there is among them a Change for good respecting the outward as well as the inward Man. They grow more decent and cleanly in their outward Dress, provide better for their Households, and get clearer of Debt."[96]

According to Park's account, the conversion and new "lifestyle" also stirred an interest in education among the tribal women, especially in teaching their children to read. Park wrote that "[a]ll that we have been able yet to do, is employ an Indian Woman to keep School in a Wigwam."

The peace between the newly Christianized Narragansett and the English congregants was not to last. An English faction under the leadership of Elder Stephen Babcock separated from the church, and soon after the Narragansett, too, when a remaining English member chastised Narragansett Samuel Niles for "exhorting in the congregation."[97]

Such was Niles's influence among the Narragansett that one hundred left with him to form a new church on the reservation.

Chapter 12
Samuel Niles and a Separatist Church

At first glance, it would seem that little is known about the Narragansett Samuel Niles. Early historians often confused him with the more famous preacher—born on Block Island, Harvard educated and also a minister to the Indian community in Braintree. Samuel Niles the Narragansett was to achieve a somewhat lesser status among the remnant of Puritan-raised preachers, but he was to have a significant influence over those Narragansett who followed the Christian faith.

According to one account, Niles's ministry began as a young man in his role as a powwow, or spiritual leader. He was close to the sachem's family and married Charles Ninigret to "Betty," the daughter of Tobias Cohes, a union that was not sanctioned by the tribe. Niles was given a tract of land by the old Queen Toccommah on which he built a small, English-style house for his family and turned his farm into a model of English husbandry.[98]

When the "new light" movement swept through New England, Niles was converted and joined Park's church in 1742. By the time of their departure from Park's church, Samuel Niles and his followers were true separatists from the constraints of the Anglican Church.

In 1750, Niles's congregation constructed a wooden meetinghouse on the place where the granite Narragansett church now stands.

Reverend Joseph Fish wrote promisingly to his friend, Dr. Sewel, in the fall of 1765 that the Narragansett "seem tender and Very Susceptible of Impressions, from Truths, peculiarly interesting. And, must confess, by the

Small experience I had of their Temper, They appeared to be of a More teachable Disposition, than I expected."

In this correspondence, Fish wrote of their spiritual leader:

This Niles, (Who I have known Some Years) is a Sober Religious Man of Good Sense and great Fluency of Speech: and know not but a very honest Man. Has a good deal of the scriptures by heart, and professes a Regard for the Bible. But his unhappiness is this, He cannot read a Word, and So is wholly dependent Upon the (too seldom) reading of others: Which exposes him (doubtless) to a great deal of inaccuracy in using Texts of Scripture, if not to gross Mistakes in the Application of them. And as hereby, (I conclude,) very Much upon the Spirit to teach him Doctrine and Conduct. [99]

In spite of having visited the Narragansett and knowing Niles "for some years," Reverend Fish apparently was naïve to believe that he could establish himself as a "teacher" among the tribe. The church of Samuel Niles was an anomaly to Fish and other rigid overseers of the Narragansett church. The English defectors from Park's congregation at first blended in with Niles's followers. Their leader, Deacon Babcock, assumed the role of overseer but did not participate in Niles's convocation as minister. The account left by Ezra Stiles, purportedly from Niles himself, showed the extent to which the Narragansett Christians separated themselves from the English:

But as none of even the Separate Elders would ordain him; the Church chose and appointed three Brethren Indians to ordain him. They began Exercise in the meetinghouse about noon and held it till near sunset. The 3 Brethren laid their Hands on Samuel Niles, and one of them viz Wm. Choise or Cohoize or OcHoyze prayed over him and gave him the charge of the Flock: during which such a Spirit was outpoured and fell upon them (as he expresses it) that many others of the Congregation prayed aloud and lifted their hearts with prayers and Tears to God. This continued for a long Time above half an hour or nearer an hour:—the white people present taking this for Confusion were disgusted and went away.

Fish began his work with the tribe in earnest about 1765, appointing a schoolmaster named Edward Deake who kept the minister appraised

of things between visits. In December of that year, he wrote to Fish enthusiastically: "The tribe is of the opinion twill answer to Build the School House But 40 feet in Length and 16 feet of Bredth, one Storey with a Strait Roof, and the Chimney in the middle with two Smokes etc."

Deake had been instructing the Narragansett children who had attended his school since June, and a week after the decision to build a schoolhouse, he wrote: "I would Inform your honour, that our School Dayly Increases: I have Had already Fifty three children under my Instruction, and Expect many more. What Gives me the greatest Incouragements is that I find them, in general, Ingenious to learn." In a postscript, he added: "I Should Be much obliged to you if you would Help me tp Some Cash-my Second Quarter will Be out the first of January." He had apparently been teaching without pay for six months.

Despite the best-laid plans, by June Deake was writing to the minister that "[s]oon after your last visit, the Carpenter called upon the Indians for his Wages…The poor Indians being unable to Answer his Demand for want of money, the Carpenter was Obliged to Labor else where."[100]

The young schoolmaster urged the minister to write and secure money for the materials and so the carpenter could be paid. Eventually, work was restored, but even by October work had just begun on the chimney, and the building was still uncompleted by early December, much to Fisk's annoyance—he had been touting the school in "fund-raising" letters.

A tone of frustration, misunderstanding and often ignorance of Narragansett traditions permeate the correspondence and diary of Reverend Joseph Fish. He complained during visits of the drinking that went on within sight of "the Lecture" and that the Narragansett mistrusted him because he was paid a salary to "bring" the gospel as a "gift." Samuel Niles himself, Fish reported, "came out fully and plainly Against them. Said these learned Ministers Are Thieves Robbers, Pirates etc. They Steal the word…It was full bitter against them."

Reverend Fish wrote most disdainfully of the persistent Indian belief that "they are also taught by the Spirit, immediately from Heaven; so have teachings above the Bible."

On May 22, 1771, the minister wrote in his diary: "It looks as if my Service among These Indians draws nigh to an end. They are all about their own business, or taking their own Ways-Some at Labour, and others at their Diversions."[101]

By mid-August, Fish wrote bitterly that he was

> [m]*uch discouraged about this Indian Mission, at Seeing the Indians So generally despise their privileges—Set no Store at All by the blessed institution, of a preached Gospel…They had rather follow That ignorant, proud, conceited, Obstinate Teacher, poor Sam Niles, than Attend regular preaching of Sound Gospel Doctrine. Rather follow, Some of their work, others their pleasures, Idleness, Drunkenness, or any Way of Serving the Devil and their Lusts, than to Spend An hour or Two in hearing the precious Truths of the Gospel.*[102]

I've included nearly the whole of Fish's diatribe because it illustrates several points about the failings of his own and others' ministry to the Narragansett and other tribes. It is plain regarding the correspondence and diaries that Fish remained perpetually confused about Indian customs: their belief in the Spirit's guidance, their long excursions from home to sacred sites and their absence during hunting and planting seasons.

Joseph Fish—like other ordained, wandering ministers seeking a mission among the natives—never educated himself in the customs and beliefs of the Indians and scarcely acknowledged the abject poverty in which they lived or recognized that it came from their dependence on white communities.

Those "at their labors" were there out of economic necessity; those at "their diversions" had often worked all week on a neighboring farm or labored on a series of menial tasks in the neighboring community for the lowest of wages. Those ravaged by alcoholism were among the many Indians ignored by charity and frowned on by the clergy, who turned their black cloaks to the cause and those who profited from such misery.

Like many evangelical ministers of his generation, Joseph Fish expected the Narragansett to adapt their way of living to the tenets of the church once they discovered the truths of the gospel. While Reverend Parks had succeeded with some Indian conversions by allowing Narragansett worshipers to slowly adapt the Gospel into their storehouse of other truths that the Spirit gave them, Joseph Fish lived mostly at a distance, relying on Schoolmaster Deake and others to keep him appraised of the mission. His diary of visits recorded his mounting belief that his mission has been betrayed by the very people it was meant to serve. But his own continued ignorance of the ways of the

Narragansett can be seen in one diary passage from May 1772, a full seven years after the school had opened:

> *Preachd to 13 Indians and a number of White people from Jno. 14.6…*
> *Had a measure of Freedom, was enabled to Open the Subject with Some*
> *Clearness; and would hope the poor Indians learnd Something. But alas! I*
> *know not What method to take, nor Argument or Motive to Use, to engage*
> *them to Attend the Lecture or regard the School.* [103]

Later that same day, Fish went in search of his Indian "deacon," John Shattucks, and found him "[b]usy at planting, but had no thought of the Lecture. Pretended he had forgot all about it."

The school itself was sporadically attended as the years passed, though Schoolmaster Deake stayed fourteen years and through letters provided some clear idea of the time. Deake's letters and Fish's diary portrayed a native community divided by land claims, the struggle that Niles and others had waged to unseat the sachem and the continued poverty that pervaded Narragansett lives.

Fish sometimes wrote bitterly about the Indians' "[i]gnorance and blindness as to the Advantages of the School and Gospel Ministry" and about the parents who "[w]ill not get wood for the school…their naked or ragged children cannot sit in the cold." But the only "charity" Fish provided was through the Indian commissioners and consisted mostly of the distribution of blankets to "the most needy persons Among them" and, at least on one occasion, while he "exhorted and Sirrd them up to Send their Children to School," the promise of "one or two pair shoes."

Reverend Joseph Fish attempted to minister to the Narragansett for ten years, leaving by December 1774 another bitter entry in his diary:

> *Preached at Mr Deake's to 3 Indians, on 1 Peter 2.2…Discoursed with Some*
> *what of Freedom, and, hope, not entirely without Sensibility. But the Indians*
> *remain Indisposed to hear Me. A Publick Training, This day at Mr. Champlains*
> *Tavern, Suppose, hindered Some few from attending the Lecture…Wrote a letter*
> *to Sam Niles to let him know I had frequently heard of his Charging the Indians*
> *not to come and hear Me preach: Which, if true, I had a right to know what it*
> *was for, and twas his duty as a Christian to come and Tell me.* [104]

William S. Simmons wrote most effectively that in establishing their own church, and resisting white overseers,

> *they strengthened the boundary that separated them from other poor and common people…their new faith appealed to and gave an organizational focus for those most actively involved in challenging the abuses of tribal and colonial authority…Finally, in Separate belief and ritual they found a vehicle for preserving some deeper aspects of their traditional culture.*

Samuel Niles ministered to the Narragansett followers long after Fish had departed. He continued to fight the sachem's indiscriminate sale of lands to Narragansett planters, petitioning the state in August 1779 and asking that the council, with the addition of "two substantial honest white People," be allowed to review and approve any sales or lease of lands. This petition did not pass but instead led the way for later legislation in 1782 that created a board, as Niles and the council had recommended. This struggle would continue to dominate the Narragansett political landscape. Niles proved to be the people's most ardent advocate, as the conflict did not end until the state intervened six years later and gave the council sole authority in approval of any further sales. It was to be his last battle.

In June 1785, the Mohegan preacher Samsom Occom, already on familiar terms with Niles's brother, James, visited "Charles Town" and recorded in his journal on June 19:

> *[W]ent in the morning to see old Samuel Niles, and found him very low, and I believe he never will get up again…went back to James, (Niles) and then to the meeting house, and was a number of people, but not large, they had but a Short Notice of my coming and I preached from Romans 4…in the afternoon went to see Sam Niles and I preached from Daniel 5:25.*[105]

In many ways, the life of Samuel Niles was emblematic of the conflicts within many of the Narragansett during this time. He initially embraced the "improvements" that the English brought in housing and husbandry. Niles never learned to read or write, but he sent his son, Samuel Jr., along with his nephew, James Jr., to learn under the supervision of Eleazer Wheelock at Moore's Indian Charity School in Connecticut, along with other sons of

prominent Christian Narragansett. The "guardians" of the young sachem "King Tom" sent him to England to receive his education.[106]

At some point, though, Niles began to negate the value of English-style education for the Narragansett. Those entries of Fish's diary wherein Niles argues against the relevance of a school in Charlestown had to have come from some personal experience or disenchantment. Joseph Fish found Niles's nephew James "a sensible man…far from being of Sam's spirit or way of conduct."

Some have suggested that Samuel Niles lost faith in the English system during his long battles with the state over the sachem's authority to sell Narragansett lands. Others seem to suggest that Niles had a bad taste left over in his mouth over much of his lifetime for the lack of acceptance he found from educated and ordained clergy beyond the reservation as a Christian leader and true minister to his people.

Spiritually, it might be said that Niles shepherded the Narragansett to integrate the best truths of Christianity into their own beliefs and their own congregation. It proved to be a strong congregation, as shown years later when another minister sought the church's acceptance. Reverend Curtis Coe, an elderly Congregationalist, attended a Narragansett service and recorded in his journal:

> *A Mulatto who is a professed preacher made a prayer. Others, also, spoke after him, some the same & others appeared to me different words. They then sung a hymn, commonly used, when they meet, from the penitential cries. "My soul doth magnify the Lord etc. etc…" After which, both men & women told their feelings…Exhortations were also given to one another… Again they sing the same hymn, as last before, took hold of one another's hands & reeled back & forward, in their devotion.*[107]

When Coe stood to plead his case for preaching to the congregation, he was astonished that everyone present (including the women) had the right to stand and express their opinion, an opinion that was as contrary as "their tumultuous, noisy meetings & what we call regular, decent worship." The assembled congregation "wanted to hear no preacher that was paid—That my preaching prevented their speaking when they felt the spirit…That their mode was for all to speak."[108]

The Narragansett had held their congregation together on their own terms, and while this was never accepted by the Society for Propagating the Gospel, local ministers came to accept the method of separatism the Narragansett practiced. In the midst of Samuel Niles's ministry, Ezra Stiles wrote a grudging acceptance in his journal: "It seems extraordinary that such an one should be a Pastor. He is however acquainted with the Doctrines of the Gospel, and an earnest zealous Man, and perhaps does more good to the Indians than any White Man could do."[109]

Chapter 13
Seeking Fertile Ground

Like the wars before, the American Revolution brought a disruption and loss to the Narragansett that were to have a profound impact on the tribe. The squaw sachem Esther died during the war, and the upstart son, George, keen on joining the American forces, was felled by a tree before even that dream was realized. That tragedy was echoed throughout the tribe, as the death or disappearance of so many young men left many widows and unsupported elderly among the population. Facing little more than the bleak prospect of further poverty on their own rapidly diminishing lands, many Narragansett chose to leave Charlestown and other Rhode Island communities.

In 1775, a significant number of Narragansett Christians had joined displaced peoples from other Algonquin tribes and moved to what would become the community of Brothertown. As the reputation of that community grew, other Narragansett followed.

John Niles, brother of Samuel, had served on the tribal council for some years and married a wife named Jerusha, who bore him three children. One, named John, who was attending Ebenezer Wheelock's Christian school, left to join the Second Connecticut Regiment at age seventeen and a Rhode Island regiment a year later in 1781.[110] However, by 1796 the family had removed to Brothertown, receiving two lots on which to begin their new life.

In 1799, John Hammer, a "prisoner for Debt which arose from his purchasing a horse which he lost by "Death," petitioned the Smithfield Friends Meeting to help him and a number of other Narragansett move to

Oneida, New York. The meeting approved the gift of more than $200 to pay off the Narragansett debts and assist with their move.[111]

This slow exodus lasted for several generations, as we find an article from the *Providence Journal* of August 14, 1843, that records a meeting held in the church amid the large annual August gathering and attended by Commissioner Potter as "the General Assembly had been informed that a number of the tribe wished to have liberty to sell their lands and emigrate… their land here was poor and exhausted; the land at Green Bay, where their brethren were, was of the most exuberant fertility."

Deacon Sekatur, the successor of Samuel Niles as the church's leader, was among the few who spoke out against the ongoing exodus. The deacon told the Narragansett who were intent on leaving that "if they were only industrious and temperate, they could get along here as well as the whites."

By the time of the deacon's plea, though, a serious migration had already occurred. In January 1833, a report by the commissioner to the state assembly provided a list of 199 Narragansett residing in Charlestown and 50 or more names of the people "who were supposedly absent." This, of course, was not the whole of the tribe; there were simply fewer families in Charlestown to speak of other relatives in other places.

A later report, issued in 1839, described the assembly's growing viewpoint of the remaining Narragansett:

> *The state of morals among the Indians has, for many years, been very low, and it has had a debasing effect upon many of the white people near them. The people of their neighborhood will, undoubtably, rejoice to have them better educated, and their morals, if possible improved, as the only way of correcting the evils they must otherwise suffer from, in consequence of their presence.*

Chapter 14
The Ghosting of a People

This growing disenchantment with the plight of Native Americans was fed by the popularity of the scientific and academic studies of race purporting the superiority of the Caucasian race and the consequential dwindling of other races in the white man's shadow. In Europe and America, these ideas stirred tensions between Americans of European descent and black Americans, as well as Native Americans, and preceded a swell of violence directed against the later immigrant tides.

The idea of racial superiority had fomented for decades by the mid-nineteenth century. In America this ideal was presented in patriotic form within the first histories written as the republic gained firm footing, so to speak, in the world. States began to publish their own local histories, as well as the communities within. Many of these histories were written by prominent and wealthy citizens of diverse backgrounds, but almost all were consumed with the Anglo-Saxon heroes of the Revolution and with the "progress" that came at their ancestors hands.

Samuel Greene Arnold's *History of Rhode Island and Providence Plantations* (1853) took a dim view of the remaining Narragansett, promoting their decline by citing "an inevitable law controlling the occupancy of the earth," and mistook Samuel Niles for the famous minister from Braintree,[112] who had visited Park's congregation. Wilkin Updike's *History of the Episcopal Church in Rhode Island* (1907) corrected Arnold on this matter but held an equally disparaging view of the people and their identity: "It was a well known custom for Indians and Negroes to assume the name of white people

of prominence, who had been their patrons or masters, a class to which this Indian preacher Niles, doubtless belongs."[113]

William F. Tucker's *An Historical Sketch of Charlestown* deemed the true Narragansett long deceased: the remnants of the tribe were of Niantic blood and shared not a drop of the blood that once coursed through the great sachems of the past.

Frederic Denison's *Westerly and Its Witnesses* (1878) compiled a chronology of Indian names and places and a reference of tools and implements used, as well as a reference guide to tribal customs and a vocabulary, before commenting on the present state of the Narragansett: "A subtle decay seems to be in the Indian nature, and it is only too evident that the remnant of the hordes of the forest must soon follow their Fathers to the land of forgetfulness."[114]

William Cullen Bryant and Sidney Howard Gay's *A Popular History of the United States* (1879) included an "engraving made from ambrotype of 'Esther Kenyon, The last of the Royal Narragansetts.'"

Among the local historians, there was none who took a more romanticized view of a heroic, deceased nation of Indians than Thomas W. Bicknell. Elected to the Rhode Island General Assembly while a senior at Brown, Bicknell became commissioner of public schools; he helped to reestablish what is now Rhode Island College. He also established a board of education and opened fifty new schools during his tenure. He supported the election of the first all-female school board in Tiverton and promoted the desegregation of public schools.

In photographs we see a man tall in stature among his contemporaries, a look of clear determination on a face framed by a distinguished white beard above the starched shirt and black tie. Bicknell's ego was equal to his stature in the community. As president of the New England Publishing Company, he produced a massive five-volume *History of Rhode Island and Providence Plantations*. Deciding that he desired a town to be named after him, he posited a proposal of his one-thousand-volume library to any town in Utah willing to adopt the name of Bicknell.[115]

He was the founder of the National Society of the Sons and Daughters of the Pilgrims, Order of the Founders and Patriots of America, and proudly proclaimed his old Nordic stock in his *History and Genealogy of the Bicknell Family*. Relishing his self-appointed role as state historian, Bicknell began

to engineer and foster the dedication of "monuments to the Narragansett tribe." He published *A Statement of the Case of the Narragansett Indian Tribe* and founded the New England Indian Council, sharing the title of "Head Pale-Faced Sachem" with another council member. While the council was open to native and nonnative members, the first few pamphlets published of the meetings revealed that only white men held the leading roles, with titles such as "Keeper of Wigwams" and lodgelike lexicons of the white man's society.

Bicknell's voluminous *History* of Rhode Island, published in 1920, borrowed much from past historians but also had its own share of notable passages. One is perhaps the most egregious whitewashing of northern slavery ever penned:

> *The Narragansett county was the slave paradise of the Northern colonies… Every farm had its quota, and the family life of the slaves was recognized and protected. Labor indoors and out was not excessive, the relation of master to slave was kind and humane, and punishments for offenses were usually mild and corrective. The social and convivial life of the masters, mistresses and young people was communicated to the servant class and the natural happy-go-easy spirit of the slaves was made more joyous by the examples of their superiors.*

In his treatment of the Narragansett, he wrote poetically of Canonchet and the heroic Miantonomo and provided a standard, romanticized version of the Great Swamp fight, citing fewer casualties than earlier accounts. He then wrote poignantly of their demise after King Philip's War, continuing the drumbeat of the earlier historians.

Bicknell ignored the later existence of the Narragansett when he confused Samuel Niles, the later Narragansett, with that of Niles the minister, of whom he wrote a brief biography, which concluded: "In his later years, Rev. Mr. Niles returned to Rhode Island and became a pastor of a church in Charlestown, composed chiefly of Indians of the Niantic Tribe."

Bicknell's enthusiasm with erecting monuments to Narragansett lore perpetuated the proclamation of the tribe's "death" on paper into the physical world. Through his "council" and by persuading communities and the state to erect these "tombstones," the public perception naturally grew that the Narragansett were a people of the past.

In the midst of the maelstrom of popular histories and a populist political climate, the Rhode Island State Assembly held meetings in 1879 and again in 1880 and 1881 to effectively dismantle the Narragansett tribe of its title and property. Citing several of the aforementioned "histories," the committee met to "[i]nquire into the Justice, Expediency, and Practicabillity of abolishing the tribal relations of the Narragansett Indians, of Conferring the rights of citizenship upon the members thereof."

The committee held three public hearings, beginning with one at the meetinghouse in Charlestown on July 30, 1879, where the committee traveled to respond to an appeal by the council for the assembly to investigate complaints about continued white encroachment. Instead, the two members present before the tribe informed them that it might be in their best interests to disband and become citizens. The first response was from Gideon Ammons, the head of the tribal council, who reiterated why he had asked them to come and remarked: "Now as it appears the State wants to dispose of our public lands, we don't wish to stop the wheels of any business. We will sell them the land for just what it is worth. We don't expect to sell it as we used it—a great tract for a little rum. We would rather have a few greenbacks than the firewater."

He submitted to the committee a sworn "deed" from Ninigret outlying the boundaries of the original reservation and told the members:

> [T]*he state has accused us of making an enormous expense for them, and here is this tract of land. The railroad passes across it. They have built upon it and don't call our property anything, but the three hundred dollars that is given to the tribe is enormous expense. Well now then, before I become a citizen I want what belongs to me. What belongs to me is mine. Congress is the third party to settle it therefore I don't wish to be a citizen until this thing is settled up.*[116]

Joshua Noka, another tribal council member, asked the representatives:

> *Why should the Narragansett tribe be willing, just for the sake of being a citizen, to throw away the rights and privileges that they now have?....Now, if we were citizens somebody would compel us to fence our lands. We can't fence them to save our lives; and if we can't fence*

our lands, suddenly the right must be forfeited. And now we are not
obliged to fence the land that we hold.

Council member Daniel Sekater, descendant of the deacon who had
overseen the Narragansett church after Samuel Niles, spoke bluntly and
addressed the prejudice that had led to the assembly's proposal:

> *I can't see for my life wherein we shall be benefited any more than we are*
> *at the present time by coming out as citizens...some argue that they ought*
> *to come out as citizens because they are mixed up with others...But other*
> *classes are mixed up with other nations as well. There is hardly one who*
> *can say I am a clear-blooded Yankee.*[117]

In subsequent meetings in August and October, the committee heard
similar protestations and testimony from a proud people attesting to their
long family history in the tribe and the state. It also heard testimony from
Charles Cross, the town clerk of Charlestown, and other white administrators,
including Indian Commissioner Cornell, who while admitting that he was
not "very acquainted with the land up there" nonetheless felt it for the
betterment of the tribe if they abolished the Indian school and the tribe's
children be sent to the town schools, remarking that "I would send my boy
to school where they went just as soon as anywhere."

Many of the tribe were also in favor of abandoning an "Indian" school
and sending their children to white schools. Many wanted more of an
assimilation into white society, especially jobs. The testimony of one Indian
laborer clearly annoyed one member of the committee, who insisted that
the skilled and educated Indians he had witnessed elsewhere, as well as
the "negroes in the senate," should be what the Narragansett wanted their
people to become.

The laborer responded: "That may be, but in Rhode Island there is no
such thing." As far as citizenship, he told the committee: "To be a citizen I
think wouldn't be any use to me. I shouldn't be permitted, or any of my sons
to be a juryman. Might do, as some one said a little while ago to dig out a
cesspool or some other job."

By the third meeting on October 31, 1879, the tribal council seemed
compelled to sell the land that the state coveted in exchange for retaining

their sovereignty. Mr. Ammons told the committee that he estimated the Narragansett landholdings to be "in the neighborhood of 14 or 15 hundred acres, all told."

The committee members scoffed at the estimated value the tribe had determined for their lands, as well as their claim as overseers of ponds within their lands. The committee asked Ammons:

> *Suppose the state should say to the tribe "We will remove the guardianship over you, take your lands and do what we like with them, and hereafter they shall be subject to taxation the same as other lands in the State, and you shall be subject to the same rights and privileges, and under the same law that any other citizen takes." Would that be satisfactory to you?*

Ammons response was brusque: "If they removed the guardianship we would stand the same as any other white man."

Joshua Noka told the committee in regard to the tribe's claims of land value that "[i]f it is worth something to the State it is worth something to us, and I say it ought to be paid for. If the land is so situated that it can be improved and made more valuable, then if we sell it, we ought to have some of the valuation."

Another tribe member, Mr. Thomas, told the committee respectfully that

> *I have thought this thing over for myself, and I look at it this way—That the State has nothing to do with disposing of our property at all. We will admit that we are under guardianship and protection from the State of Rhode Island, but I don't think the guardian has any right to sell our land and make us expense. If the state sees fit to raise the guardianship, then we stand as we were before. I don't think it would be any new thing for them to do it, and then what belongs to me, I have a right to ask for. I don't want the State...to sell this property and disenfranchise me from the property that belongs to me, and that I inherited. Give me my right.*[118]

Following the public hearings, the committee met with tribal leaders behind closed doors, eventually reaching an agreement for the sale of the lands except for 2 acres that included the land on which the Narragansett church stood. On the basis of the committee's report, the Rhode Island

Assembly voted to abolish the tribal status of the Narragansett. The assembly estimated that only 922 acres of the more than 1,500 acres claimed actually belonged to the tribe and determined that the assets from the sale of those lands would go to individuals who could claim tribal ancestry—but only after the state undertook a long and tedious process to determine tribal genealogy, contesting the testimony of dozens of tribal members who had come long distances to speak in the public hearings and whose families had long taken part in the August gatherings and voting for the tribal councils.

With this act, and the subsequent division of their lands, the "ghosting" of the Narragansett was complete, at least in the minds of those state politicians and Charlestown officials who had long wanted to make the tribe accept ordinary citizenship. For others, like Thomas Bicknell, Frederic Dennison and more, the act gave license to continue the promotion of public monuments and establish the evacuation of grave sites, a further "ghosting" in removing artifacts from graves and placing them on public display.

Despite these degrading acts, whether based on true archaeology or, more often, undertaken by eager, amateur historians, the people of the Narragansett would prove resilient and reclaim their sovereignty, though it would take nearly one hundred years to wrest it back from the state.

Part III

THE RETURN OF SOVEREIGNTY

Chapter 15
A People of the Past

As the nineteenth century unfolded across the country with unprecedented changes in industry, transportation and population growth, even the smallest of states in the republic were affected in new and profound ways, as well as all of the people therein. For the Narragansett, it proved to be a century of continual change, as longtime natives gave up their land, joined other groups and moved on from what had been years of desperation and hopelessness. By 1842, the farmer who owned the land Miantonomo's grave was located on had never seen an Indian come near and so dismantled the cairn and used the stones that had lain for centuries to build the foundation for a new barn.

When the state detribalized the Narragansett in 1883, those people who remained were described as little more than a remnant of what "had once been a proud tribe."

The minds of New Englanders had long been captured by Indian narratives of adventure or captivity, accounts of encounters and lives shared with Native Americans, as well as the treaties printed by Ben Franklin in America. The young nation's emerging literature also played an inestimable role in what framed the picture Americans had of local Indians. One such mind was that of Henry David Thoreau, who late in his young life met Martha Simon, "the only pure-blooded Indian left about New Bedford," believed by locals to be a Narragansett.

Thoreau sought out and found the elderly woman "alone on the narrowest point of the Neck"[119] and wrote somewhat disappointedly:

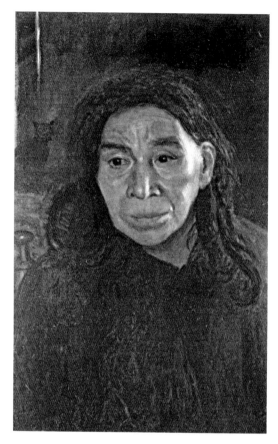

Portrait of Martha Simons. *Courtesy of the Millicent Library.*

"To judge from her physiognomy, she might have been King Philip's own daughter. Yet she could not speak a word of Indian, and knew nothing of her race. She said she had lived with the whites, gone out to service for them when she was seven years old."[120]

From early in his adult life, Thoreau had kept a series of notebooks filled with quotes, odd facts, historical references and personal experiences with Native Americans. He intended to one day collect enough material for a definitive work. As Robert F. Sayre points out in his book *Thoreau and the Indians*, followers of the naturalist and transcendentalist essayist believe that he would have penned a "book about Indians free of prejudice, rhetoric, and melodrama, depending instead upon poetry, or the exact imitation of real life in the right images."[121] Such an achievement would have been a long struggle for Thoreau, "for he certainly began his literary vocation and his early pursuit of Indian relics and lore under the spell of Savagism."[122]

Martha Simons was also portrayed by the young Albert Bierstadt in 1857 after his return from painting lessons in Europe. Bierstadt subtitled her portrait *The Last of the Narragansett*. While the legend of her ancestry was later questioned, the portrait of this woman is also a portrait of a people, and her story was the life that many Narragansett and members of other remaining tribes were living at this time.

Natural scientists like Thoreau, as well as historians writing from the Anglo-American tradition, were veiled in their view by the earlier histories in how they saw the native population. Even as an American generation that was for the first time breaking from European influence, these historians and wanderers—and experimentalists like Thoreau, leading the followers of natural science onto the path of anthropology—still saw the remaining members of the Indians they observed and interviewed as the fragmented remnants of the people of their inquiry.

The disturbance of Indian graves by English settlers began within two weeks of the Pilgrims stepping ashore in 1620. A party of armed men, sent inland, walked six miles or so and found an Indian burial ground, where, according to Edward Winslow's journal, they dug up and discarded a number of bones but kept "various pretty and sundry items."

An attempted robbing of a Narragansett grave occurred as early as 1653, when a Dutch trader and his crew were caught in the act of desecrating the tomb of the sister of Sachem Pessacus. The robbers reputedly fled empty-handed to Warwick with a band of angry Indians on their trail.[123] As chronicled by Howard M. Chapin, there were numerous occurrences of accidental discoveries as well, such as the unearthing of an Indian grave along the banks of the Sakonnet River in Tiverton in 1834 and the excavation in 1835–36 of numerous artifacts by the workers constructing the railroad between Westerly and Providence. Workers constructing another railroad bridge unearthed an Indian cemetery just west of the city in 1848.

Artifacts collected from these sites were given to local historical groups and to the Rhode Island Historical Society. These accidental discoveries were of keen interest to the amateur historian and academic alike. Collecting skulls and artifacts had become increasingly popular as a "hobby of gentlemen,"[124] especially to those interested in the theories of cranial capacity as a determining factor of intelligent race. Local "gentlemen" and their societies were no exception, and perhaps these accidental discoveries fueled the passions of more than one individual to commit the desecration of Narragansett graves.

Chapter 16
The Sacrilege of Sacred Ground

In 1859, workers led by Dr. Usher Parsons excavated two graves long suspected to be those of Sachem Ninigret and his daughter in the ancient "Royal" Burial Ground. Parsons described the site at the time as "a swell of land covered by a dense forest. Through the center of this, and running from East to West is a strip of ground ten feet wide, and raised two or three feet above the adjoining land and supported on each side by a stone wall…the only lettered gravestone is to the east end."[125]

The workers unearthed a body interred in two halves of a hollowed log— as though to imitate an English coffin. Parsons later wrote of the female remains they had found: "Her dress and ornaments denoted that this was a female of exalted rank, and she was buried in the west end of the Sachem's cemetery, where internments first commenced." The body was

> *enshrouded with a silk robe, and on its head a cap or bonnet of green silk. Extending from the top of the head, was a chain like a watchguard, down to the sole of the foot…Surrounding the waist was a belt made of wampumpeag, and covered with silver brooches, as ornaments. Around the neck was a necklace, and at the waist were silver sleeve buttons. They also found two Dutch coins, one of silver, dated 1650, and a copper farthing.*

The supposed grave of Sachem Ninigret, who had died twenty years after his daughter, was disappointingly devoid of any ornaments, only leaving a

"skull and other bones that present exactly the appearance we might expect to see in the skeleton of Ninigret."

Parsons was a distinguished surgeon and wrote many medical texts, including one on seasickness and its remedies for the U.S. Navy. He was also, as were many men of wealth and standing, an amateur historian. Among his histories was a review of the Battle of Lake Erie, during which he attended to the wounded as a young surgeon. Parsons also held a fascination with the Narragansett and published *Indian Names of Places in Rhode Island.*

In the years following the exhumations, Parsons reported his findings in talks at both the Rhode Island Historical Society on October 7, 1862, and the New York Historical Society the following year, exhibiting the artifacts, including the skull and femur of Ninigret, to his audiences.

As reported by the *Providence Journal,* Dr. Parsons told his audience that two years before, "with a view of ascertaining the posture of the buried remains, Mssrs Joshua P. Carrd, Asa Noyrs, Samuel Nocake, Charles Cross, Christopher Card, George E. Mattison, George F. Babcock, and Oliver Fiske, lately opened one of the graves in the Sachem's cemetery in Charlestown, R.I."

The *Journal* recounted the dramatic efforts of the men: after digging four feet, they

> *came to three very large flat stones, weighing perhaps a ton each. Raising them out of the way, they continued digging four feet deeper, including the thickness of the stones. They then struck a large iron pot filled with smaller pots, kettles, and skillets. They found also a large brass kettle, filled with porringers and other kitchen ware and bottles.*

It was beneath these items that the great hollowed-out log, chained and padlocked and containing the body of the princess, was found.

Due to the location of the bodies, and also to the Dutch coinage found with the body, Parsons concluded that the graves held the remains of a young daughter of Ninigret and the sachem himself. Another local historian, Sidney S. Rider, disputed Parsons's conclusion, declaring that the grave he had unearthed belonged to Weunquesh, elder sister of Ninigret II.

Howard M. Chapin took this theory further with his argument that the method of burial would surely not have been used in 1660; by 1686 or 1690,

when the squaw sachem died, an adaptation of an "English burial" would have been more likely.

According to Chapin, after these artifacts were displayed in the Rhode Island Historical Society, "the relics from the Sachem's grave" were dispersed. At the time of his article in 1927, Chapin wrote that "[t]he skull of the princess, the spoons, some pewter porringers, a piece of iron chain, some beads, and one of the so-called brooches" remained at the Rhode Island Historical Society. The Peabody Museum at Harvard accrued some of the artifacts, and others went to at least one private collector.

Parsons was not the only person at Brown with anthropological yearnings. In 1917, an essay in the *Brunoniana* bemoaned the fact that "we only have one skull and the bone of a femur" to claim any collection of natural history. In papers published in *American Anthropologist* in 1912 and 1923, Harris Hawthorne Wilder mentioned a "small square cabinet of glass and rosewood, containing a female skull, with the mandible missing" in Brown University's Arnold Hall. The author referred to an earlier account that the skull came to the university by way of Dr. Parsons's son and had been displayed since that time. H.H. Wilder was an anthropologist teaching at Smith College when he first encountered the skull. Today he is considered the "father" of forensic medicine for his work in facial reconstruction.

Dr. Wilder's paper in 1912, "The Physiognomy of the Indians of Southern New England," published in the *American Anthropologist*, describes the skull as "having real historical value, being that of the daughter of the Niantic chieftain Ninigret," and thanks Dr. Albert Mead, the "present director of the museum there," for entrusting the skull. Wilder wished to apply current European methods for reconstruction:

Interested now for several years in these European attempts at reconstructing faces upon skulls, I determined to apply the methods to the skulls of New England Indians, in a region the extermination of this race has been so complete that no living representatives are now left except two or three small communities where intermarriage with other races, especially negroes has been long continued (e.g., Gay Head Mass; Charlestown R.I.).[126]

In the summer of 1912, Wilder and his wife, Inez Whipple Wilder, a fellow anthropologist, obtained permission from the Town of Charlestown and the

Wilder's reconstruction of "Ninigret's daughter" from the January 1923 *American Anthropology*.

owner of the property on which the ancient "Royal" Burying Ground rests to excavate ten graves. The Wilders claimed to have found two graves already emptied, including one whose tombstone Parsons had referred to sixty years before: "Here lieth ye Body of George ye son of Charles Ninigret, King of ye Natives and his wife Hanna." The footstone indicated that the grave was that of an infant, dying less than a year after birth in December 1732. The Wilders exhumed eight Narragansett bodies and brought the remains back to Smith College, where they were displayed in the Anthropological and Zoological Museum at Burton Hall.[127]

In his 1923 article "Notes on the Indians of Southeastern New England," Wilder's reconstructed Narragansett "princess" was featured along with a newly constructed bust created by Miss Eunice E. Chase.

In recounting the background of the skull's discovery, Wilder repeated Parsons's story as written in his 1863 article in an almost folksy manner:

In Charlestown in 1859 a discussion arose one day among a group of young men, two or three of them being of Niantic-Narragansett blood, about the method of burying their dead formerly practiced among the local aborigines….Not coming to a satisfactory conclusion with the data at hand, some one proposed that they repair to the old Indian burial ground a mile away, and dig up a body as a test case.

This supports Wilder's earlier account in 1912 that "her body was exhumed in 1859, apparently out of curiosity, but by good fortune came into the possession of Dr. Usher Parsons of Providence."

Concerning the other artifacts found within the grave, Wilder wrote:

Many of these seem to have been distributed among the diggers as individual mementos of the occasion; other things are reported to have been sent to the collections at Brown University…What the condition of this skull was, when presented exhibited by Dr. Usher Parsons, whether it had lost its jaw, whether any of the other bones had been preserved, and what happened to the silk green dress, the remains of the moccasins, and the silver chain, are questions that are now unanswerable.

There are several difficulties that present themselves with this account, and I endeavor to discuss them in an effort to clear up the misunderstandings that were apparent, as well as offer an insight into the grievous mishandling of these remains and artifacts.

First, the condition of the "princess's skull" was duly noted by Parsons in his article "Indian Relics" published in the *Historical Register* of February 1863: "The skull…was in a fine state of preservation. The sockets of the teeth were symmetrical and perfect, indicating a fine set of teeth, and the form of the head was well proportioned. The hair was neatly dressed and abundant."

This would seem to reference a different skull than the one in Arnold Hall, a difficulty that Wilder referred to in his paper—"the hair when exhumed was in great quantity…now only a few course patches remain of light brown"—and Parsons made no further reference or offers any description of the skull he extracted with difficulty from the second grave. A photograph in Alice Collins Gleeson's *Colonial Rhode Island*, published in 1926, is of a

display from the Rhode Island Historical Society of a section of "Wampum Belt" and a long sheaf of hair "found in an Indian Grave." This is likely the princess's hair shorn from the skull for display.

The reference to a skull at Brown University's Arnold Hall indicates that this artifact, presumably under the care of Parsons and later his son, was given to the university some time after Usher Parsons's death in 1868. A question still lingers, however, in my mind as to the true identity of this skull. With sixty years having passed, would the mishandling of the skull, other bones and artifacts result in the condition of Wilder's "princess"?

It is unlikely that those citizens, including those of "Niantic-Narragansett" blood, would offer relics to Brown or any other institution, being robbers employed more likely by private collectors or by dint of curiosity and perhaps in the hope of privately selling some artifacts. It may be that the current owner of the property gave the men permission to excavate the long burial mound.[128]

William F. Tucker, in his book A Historical Sketch of Charlestown, places Parsons on the scene—not just once but rather he opened "quite a number of graves" in his subsequent visits to add to his collection. Wilder alludes to subsequent visits by Parsons as well in his paper. Members of the Narragansett tribe filed charges against Parsons and the others, but the Rhode Island Supreme Court exonerated the accused and their case was never heard.

Records from the Rhode Island Historical Society show that Brown University donated the skull and the sculpture, now catalogued as that of Weunquesh, on March 24, 1925.[129] There is no further reference found to illuminate what happened to the skull of Ninigret, assuming that was the identity of the second skull unearthed by Parsons.

According to recently interviewed librarians and scholars at Brown, the skull and other artifacts likely became part of the Jenks Museum at Brown. This was Brown's first museum of natural history, painstakingly collected and catalogued largely at its curator John Whipple Potter Jenks's expense. An eccentric naturalist and expert taxidermist, Jenks began his collection in 1871, hoping to model his museum on the successful Museum of Comparative Zoology at Harvard, founded by Louis Agassiz in 1859. Unfortunately, funding was problematic over the years, and despite Jenks's repeated efforts to secure funds from the university and outside donors, it never attained the standing of Harvard's museum.

Jenks's taxidermy class of 1875 on the steps of the museum. Note the two gentlemen holding skulls on the extreme left and right of the photo. *Courtesy of the Brown University Archives.*

Despite these setbacks, the collection that Jenks came to assemble proved to be of popular interest. In 1893, the *Providence Journal* noted that "[i]n the absence of a city museum of Natural History, the Brown University Museum has attracted a great deal of attention during the last few years and has been visited by scientists in search of knowledge and the general curiosity seeker." Alumni also offered generous donations acquired in world travels, and it must be assumed that the collection came to the attention of Dr. Charles Parsons and that the skull in his care was duly donated. In 1891, Jenks divided the large collection he had amassed into two collections, one that remained as the Jenks Museum of Zoology and the other that became the Museum of Anthropology.

Jenks died on September 24, 1894, literally on the steps of his museum, and upon his passing, the collection began a long and strange journey. The collection was administered for a short time after the professor's death by his assistant, Herman Carey Bumpus. Upon his leaving the university in 1900, the collection was without an overseer. A fire in Rhode Island Hall in 1906 destroyed a part of the collection, as well as Jenks's records.

The museum display in Rhode Island Hall. *Courtesy of the Brown University Archives.*

Wilder's mention of Mead as the curator, a professor of biology at the time, seems to indicate that the care of the collection was tenuous at best. In 1915, the Department of Biology was moved out of Rhode Island Hall, and the greater part of the collection was placed in storage at various locations—Van Winkle Hall, Robinson Hall and Arnold Laboratory were some of the buildings used to house the boxed-up artifacts. Only the birds and other animals that Jenks so meticulously preserved remained in Arnold Hall, with the skull in the rosewood and glass display.

Lacking space and apparent interest in a natural history museum, Brown began to disperse the collection as early as 1915, giving a number of objects to the Rhode Island School of Design Museum, and by 1931 had also donated artifacts to the Roger Williams Park Museum of Natural History. In 1954, an effort was made to donate the part of the collection stored in Van Winkle Hall to the Park Museum, and after some negotiating, the director, Mirabelle Cormack, arrived at the school with an assistant to collect the items: "We lugged those heathen idols, etc. home. They were covered with the dirt of ages. We cleaned them up, cared for them, and have them on

display, all integrated with our own specimens, and filling in many spaces where we had little or nothing."

The remainder of the collection was stored in Van Winkle Hall and offered up to any interested institutions. In an infamous tale perpetuated by J. Walter Wilson and the *Encyclopedia Brunoniana*, no institutions wanted the objects, and Wilson, knowing that Brown "owned a dump on the banks of the Seekonk River," deemed this a "suitable storage place" and "dumped 92 truckloads" beside the river. This proved, however, to be only part of the collection, and in 1962 the anthropologist Dwight Heath and his wife recovered boxes stored in the attic of Van Winkle Hall just hours before its demolition, packing up their car and driving the objects to the Haffenrefer Museum in Bristol.[130]

Parsons's desecration of Narragansett graves, and then Wilder's mass exhumation and removal of "Royals" from the ancient burying ground, were acts that these men "justified" on behalf of science. But this idea was really a continuing thread of the earlier narrative that has led historians and then anthropologists to see the Narragansett only as a people of the past.

Chapter 17
Romanticizing the Past, Reneging the Future

I n observing a people in the shadow of elders who have long been portrayed as the heroic, if not tragic, Native Americans of pure blood, a certain disdain for the remaining lineage of these heroes inks out on the page.

Parsons wrote that after King Philip's War the remaining Narragansett "remained in a deteriorate, and declining state, addicted to vice and intemperance," but he saw hope among the Christian Indians he met that the Narragansett had become "within a few years past…a moral, religious and industrious people, and are enjoying the privileges of education."

In Wilder's papers, this sometimes rises more blatantly to the surface. In summing up the historical record of the people of the princess that gained him such reputation, the anthropologist wrote:

> *Thus the descendants of the Niantic sachems, together with those of less royal blood, and blended with a Negro strain, have now disbanded tribal relations and are lost in the general current of "Americans"…In and about Charlestown we see them everywhere, serving mainly as farmers and farm helpers, while the more enterprising find their way into Providence, and serve as chauffeurs, hotel porters, and care-takers.*[131]

During this period, in a continuation of placing a physical stamp on this public imagining, societies of influence engaged in the construction of monuments "celebrating the Narragansett past," while their descendants

struggled to maintain their culture in the society they'd been forced to join after detribalization.

The aforementioned Thomas Bicknell played his role among the influential of Providence with his Indian Council of New England. The Rhode Island Historical Society, and local organizations as well, created a plethora of monuments and, as Patricia Rubertone describes, "memory-making places," which were dedicated at locations throughout the state between 1883 and 1928.

The movement began with the dedication of Fort Ninigret in Charlestown, the preservation of their early encampment as a centerpiece of the Narragansett council's agreement to dissolve tribal status and become state citizens.

On August 30, 1883, a handful of Narragansett joined nearly one hundred people, including Rhode Island's governor, the mayor of Charlestown, the town council and other state and local dignitaries. In the crowd also were historians and members from the Rhode Island and various other historic societies, as well as reporters and photographers on the grounds of their old fort.[132] It was now enclosed with a decorative wrought-iron fence, and at its center rested a massive boulder on which words proclaimed the Narragansett and Niantic tribes as "The Unwavering Friends and Allies of our Fathers."

Among the handful of Narragansett who attended the ceremony was Joshua Noka, who had spoken so forcefully in the hearings against detribalization. When he addressed the gathering—after the host of white speakers, a chorus and the recitation of a grandiose poem—he did not offer words of reconciliation but rather "spoke of the scorn and the impatience of some of the tribes white neighbors, who had lobbied for detribalization."[133]

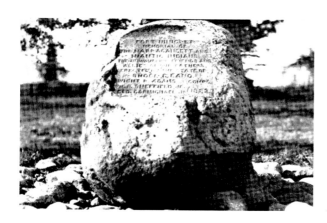

An early photograph of Monument Rock at Fort Ninigret, Charlestown, Rhode Island, from Chapin's *Sachems of the Narragansett*.

Miantonomo's monument, erected in 1841. *Photo by author.*

Noka saw a troubled future, a turbulent time in the wake of the tribes loss, and he wanted to reaffirm the existence of his people before these white visitors who had flooded to this funereal ceremony.

"We have the same blood running through our veins that we had before we sold our land," he told the gathering. No one else among the delegation of Narragansett spoke but rather sat silently throughout the proceedings.

Less than two weeks later, in an even more extravagant ceremony, the Rhode Island Historical Society dedicated a "rude, rough, and rugged" boulder as a memorial to Sachem Canonicus in the city's newly renovated North Burial Ground, the park-like environs around the monument offering great appeal for those seeking a final destination.

On the large boulder was carved the sachem's name in English, as well as a primitive bow and arrow in imitation of the signature Canonicus had used in his deed with Roger Williams and other early Rhode Island settlers. This was the second monument erected to a Narragansett sachem. After the large cairn to Miantonomo had been dismantled, the town erected a

granite tombstone in its place in 1842. In Providence in September 1883, among the nearly one thousand people at the occasion was Moses Prophet, a Narragansett who had been chosen to unveil the monument even though the state had determined that he had no claim as a tribal member.[134] The only other Narragansett present amid the throng was a little girl named Annie Thomas, who presented a bouquet to the commissioner of Indian affairs during the ceremony.

In 1906, the Societies of Colonial Wars in Rhode Island and Massachusetts erected the massive, rough-hewn granite column on the site of the "Great Swamp Fight." It is today, as it was then, a place of utter isolation. It was a somber ceremony befitting its location, with a steady rain falling "as if the clouds shed tears over the memory of the bloody scene recalled by the memorial about to be unveiled."[135] Frederick Rowland Hazard, representing the five Rowland heirs on whose land the monument stood, presented the deed of land to Wilfred H. Munro of the Rhode Island Historic Society in the "Indian custom" of passing the title by deed, turf and twig.

Munro's speech in response was "necessarily short because of the heavily falling rain, and immediately the veil was torn away by three of the Indians present."

Chaplain William M. Bodge ascended the mound before the monument and dedicated "this rugged granite shaft, frost-riven from the native hills, untouched by the tool of man as a fitting emblem" of the "rugged and

Early photo of the Great Swamp monument, from Chapin's *Sachems of the Narragansett.*

unadorned" settlers who had fought in King Philip's War but also to the "brave Sachem of the Narragansetts, who here fought valiantly for his rights, his people and their homes." Bodge acknowledged the three Indians present as descendants of "the noble but now almost vanished Narragansett tribe" and offered a prayer of peace.

The Hazards present and others performed the ceremony of "beating out the bounds" and "[t]hus ended the exercises in the Direful Swamp."[136]

In his oration that afternoon at the Memorial Hall in Peacedale, Rowland Hazard spoke of the Narragansett as "confessedly the most powerful and richest, as well as the bravest and most capable, of all the New England tribes." Hazard repeated the oft-quoted refrain that the Narragansett had been "a true friend" to the English and regretted that "[t]he leaders of our Colonial forces yielded to the bitter feeling of the baser sort among their followers and friends, and set forward to dealing a crushing blow to the Narragansett."[137]

The list of contributors to the Great Swamp Fight monument revealed that all were given in memory of the colonial soldiers who died in the battle. Only two were from Rhode Island, and once the ceremony was over and a generation gone, the monument became merely a solitary blight on the landscape.

In the first three decades of the new century, there was a fervor among those who wished to deed and entrust such commemorative places on the urban cityscape or in historical locations in Rhode Island. The Rhode Island Historical Society, in the edition of its newsletter of January 1921, reports from the committee that more than forty plaques had been installed around the state in the past years.

Thomas Bicknell, especially, was devoted to monuments and commemorations of the past. He wrote in his text *American Education* that "patriotic exercises, hero days, memorial pageants, monuments—all testify to the intensity of the group instinct. The pupil needs also to learn humility, sacrifice, cooperativeness. It is less important for him to insist on his rights than it is to stress his duties and privileges."

Bicknell first erected a monument in his hometown of Barrington in recognition of the town's black slaves and servants' "valuable domestic and patriotic services before and during the Revolutionary War." An impressive boulder of white quartz, bordered at each corner by black columns "emblematic of the interdependent relations of the white and black races,"

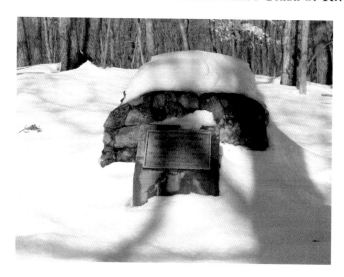

Marker at Nine
Men's Misery. *Photo
by author.*

the monument was dedicated in 1903 "[i]n memory of Negro servants and their descendants who faithfully served Barrington's families."

In 1907, he lobbied local civic leaders and the historical society for a plaque commemorating the fight led by Captain John Pierce against the Wampanoag encamped nearby in the swamplands above the Blackstone River. The plaque was duly dedicated in the heart of urban Central Falls, where it sat mostly unnoticed by the poor, millworker folk whom the educator hoped to illuminate through these physical reminders or markers of history.

Bicknell was also instrumental in aligning Wilfred Munro of the Rhode Island Historical Society in erecting a slate tablet at the site of Queen Ponham's fort in 1927; a decade later, the RIHS cemented a long-standing cairn and erected a plaque at the site a short distance beyond the Blackstone, where the nine men captured by the Wampanoag were executed and left beneath the cairn for the colonial soldiers to find.

Other monuments and memorials also became fixtures on the New England landscape. In Westerly, the long-admired sculpture of Canonchet still resides by the harbor, along with newer tributes to the Narragansett along South County's shoreline.

It could be noted that despite these ceremonies and designations of historical areas, these were—with the exception of Fort Ninigret and, with some evidence, the Cumberland site—merely sites of white historical interest and were not adopted as Narragansett places of memory.

Chapter 18
Sites of Narragansett Memory

G radually, and with more abundance as the twentieth century developed long-undisturbed lands, these sites have been uncovered. The oldest of these have been a perennial source of debate among historians, Indian elders and other interested parties. One Narragansett historian wrote in the 1930s of her grandmother telling her of "old Indian graves tucked away off on the hillsides"[138] that could only be reached on foot in the dense forests.

The discoveries of stone cairns, long described by elders and some historians as sites of Indian burial or sacredness, have come to be refuted by other historians and, more recently, in court by lawyers representing land developers. Some historians have speculated that the cairns like those discovered in Smithfield—and protected in Coventry, Rhode Island—are simply the result of a farmer's toil to rid the soil of rock; however, in the standard form of English-style husbandry, which these settlers would have practiced, some frugal use of the stone would have been found: for a stable, a well or any number of necessities on a New England farm.

Archaeologist Frederick Meli told the *Providence Journal* that the site in North Smithfield "was in use by Native Americans and it contained these mounds. Whether they're burial or ceremonial, I think they go back at least a couple of thousands of years."

The site is actually located near the scene of a deadly battle in which the Narragansett, having been pursued from the Queen's Fort, made a stand at the swampland, where on July 2, 1676, "[t]he English cavalrymen, assisted by their Indian allies, fell upon the Narragansetts, and killed all the warriors

A natural gateway to the swamp at Nipsachuk. *Photo by author.*

who were defending the swamp. The victors rushed into the swamp, killing and capturing the rest."[139]

Narragansett preservation officer John Brown acknowledged the history of the site on Nipsachuk Hill. Narragansett had gathered there for sunrise ceremonies and other ceremonies into the 1960s or 1970s, when conflicts with property owners halted the meetings: "We would meet there and discuss that it was a meeting place of our ancestors, and that we come at this time to give acknowledgement of those people that have passed."

In 2008, the tribe fought a land developer determined to build a 122-lot subdivision on the property and, with the assistance of the town, filed suit to have the site declared a historic burial ground. In 2009, the National Park Service granted an award to the Rhode Island Historic Preservation & Heritage Commission and to the Narragansett tribe to "examine documentary records and archaeological collections, collect tribal and Yankee oral histories and use military terrain analysis to identify likely places where…the battles took place."

In numerous locations throughout New England and beyond, evidence of native sacred places lie literally at our feet. In woodlands still largely undisturbed are cairns, rock piles and the playful adaptations of stone to turtles, hares and other creatures. We find them inland along the lengths of a swampland, which seems to have been more a gathering or a ceremonial place. In a hillock above a field stands an impressive boulder, within sight of a walking path.

This page: Sites in the region of Camp Swamp. *Photo by author.*

There is no path tread through the woods to this place. It seems unnoticed. A glance around finds other stones planted in a specific design before the larger stone. About ninety yards away, in a direct line from the center of the stone, I found an old mound. I could not comprehend the meaning of the place, but I recognized it at once as having *some* meaning, as a place of ceremony or simply perhaps a landmark to indicate place or direction.

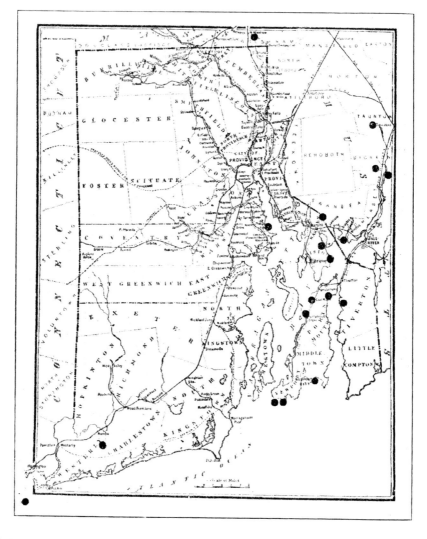

Delabarre's *Map of Inscribed Rocks on Narragansett Bay*. *Courtesy of the Rhode Island Historical Society*.

At the land's edge, also, are remnants of the Narragansett past: runic-like messages carved on rock, only visible at low tide; other rocks along rivers and shores sketched with pictographs; and an unknown script, faded from time's glare.

Perhaps the most complete and authenticated record of these rocks was compiled by Edmund B. Delabarre, a local historian on Indian sites who published his searches in a series of articles titled "The Inscribed Rocks of Narragansett Bay" in the *Rhode Island Historical Society Journal* during the 1920s.

Delabarre tracked down legends and earlier written accounts. Ezra Stiles had been a early recorder of these "written rocks," often drawing a facsimile of the figures and markings in the journal he kept of his travels. Earlier local historians had also mentioned rocks at various locations, often musing toward a Nordic visitation as an explanation for the markings. Delabarre located and reported on the present condition of these rocks in his articles, relating, for instance, that the characters on the Mount Hope rock, long yearned by historians to be a Nordic inscription, were, in fact, identified to be Cherokee and likely written by Thomas C. Broaner, a "mixed blood Indian married into a Massasoit clan and an admirer of King Philip."

The crude but fanciful Indian figure thumbing his nose at a set of distinctly different figures on Mark Rock off Conimicut are said to be Miantonomo's last word to the white settlers to whom he'd sold the surrounding land.

Other rocks were more mysterious, but Delabarre catalogued what he found to be authentic sites in Warwick, Tiverton and Warren, as well as other areas, and reported that what was long believed to be a documented site

Drawing of pictographs on Mark Rock, as etched by Delabarre. *Courtesy of the Rhode Island Historical Association.*

One of the older stone cairns that mark sites throughout the region. *Photo by author.*

in Portsmouth was now lost. The inscribed rocks had been taken from the beach by the town at the turn of the century and used in building a new dam.

In some cases, the rocks held petroglyphs and inscriptions from several generations. Time and the elements have mostly erased the markings on what sites remain today. Mark Rock was reportedly completely covered by the 1938 hurricane and was partly exposed only recently. Some are located on private land, and others are accessible only by kayak or canoe, as they were when inscribed.

These places, in particular, speak to me of resilience, which is in character with the people with which many of these sites are associated. For while these native places were being discovered and written about, the Narragansett were reestablishing themselves as a people in the wake of the state's detribalization and monument making.

Chapter 19
Reviving a Nation

Ironically, it was one organization of Bicknell's founding that became a central activist network for the Narragansett. By the 1920s, there were individual tribal members researching Narragansett history and customs. Bicknell's own enthusiasm for Roger Williams's writings led to his and the council's efforts to use Williams's *A Key* as an educational tool to relearn Narragansett language and traditions.[140]

In 1925, the Indian Council of New England joined the National Algonquian Indian Council, thereby strengthening their numbers. This organization, along with the American Indian Federation, actively promoted lectures by Native Americans on Indian culture and staged massive powwows, encouraging local tribes to research their own traditions and adapt tribal dress for these public events.[141]

For many tribes in the Northeast, little of their culture remained for them to draw on, and the popularization of pan-Indian expression—of adapting western-style native dress and dance, along with rhetorical speech and "Indian" names—became prevalent. But as Ann McMulen noted, "Pan-Indianism allowed native people to be recognized but simultaneously created a generic Indian culture that masked local specifics."[142]

Though the Narragansett were less inclined to adapt pan-Indian dress and rhetoric for their events, they participated in public powwows as an opportunity for exposure and also as an act of solidarity with other participating tribes. Indeed, there were many Native American tribes enduring similar struggles with state and federal authorities. Large gatherings in select locations elicited

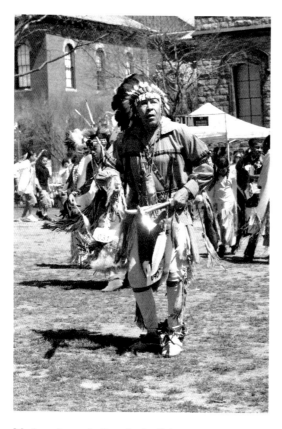

Modern dancer in "pan-Indian" dress. Photo by James M. Allen.

great interest among tourists and local historical societies during this time.

For the Narragansett, this was a period of regathering, during which the tribe saw the return of some tribal members from Brothertown, Wisconsin, whose relations had moved with others from New York generations before.

The Narragansett church and adjoining property became a focal point for Narragansett resurgence. Tribal meetings were held in the church, and the August gatherings were held in a large field nearby. These events continued the traditions of oral storytelling, individual dances and competitive games.

The Narragansett adapted some western-style dress in public powwows that showed an influence from the Brothertown Narragansett who had attended western-style gatherings in Wisconsin.

Individuals from eastern tribes also began to adopt the western tradition of public gatherings to celebrate their heritage and even give lectures to the public on native history and way of life.

One such person was Princess Red Wing. Born Martha Congdon of the Wampanoag, she became well educated and began researching the history of her relatives, the Narragansett and their legal battles with the state. In adopting the name of Princess Red Wing, she was following a trend among modernized Indians to adapt names and rhetoric, especially at public powwows that were familiar to white listeners. She became an outspoken

and familiar figure throughout the state and nation, spending much of her adult life as a teacher to both dignitaries and schoolchildren and explaining that, like the blackbird, she was "to fling her mission far with grace, for ears that harken for the uplift of my race."

In 1934, she began the publication *Narragansett Dawn* in an effort not only to keep communication open between members of the tribe in Charlestown and those scattered about the country but also to highlight the history of her people by publishing stories and contributions from Narragansett writers, a sometimes uneasy transition from the tradition of oral histories.

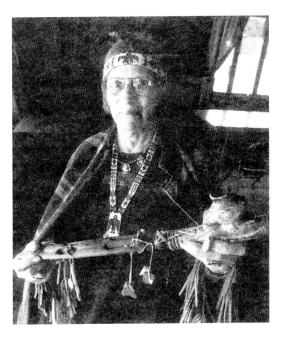

Princess Redwing, with a ceremonial pipe handed down in her family for generations. *Courtesy of the Warwick Historical Society.*

Princess Red Wing was also active with the Indian council in ensuring a Narragansett presence in the Rhode Island Tercentenary Celebrations of 1936 and in the dedication of the Roger Williams memorial. In a lavish ceremony, a contingent of Narragansett walked with the assembly and assorted dignitaries in solemn procession to the memorial, though their presence was cropped from the *Providence Journal* photo published in the paper the next day.

Reverend Harold Mars could trace the family lineage from his father, White Buffalo, a preacher of some renown among Christian Indians, back to Samuel Niles himself, the founder of the Narragansett Indian Church. Mars earned five dollars a day during the 1940s, preaching to congregations in Providence, Peace Dale and Wakefield. He later moved his family to Rochester, New York, where he led another congregation for more than a decade. During those years, his family always returned for the August powwow, and Reverend Mars would preach in the Indian church on Sunday.[143]

His son, Roland, carried on the calling into the turn of the century, preaching to a smaller congregation as many younger Narragansett turned away from the religion that "came over on a ship" and returned to their ancestral beliefs.

A native Rhode Islander who came into national prominence during these years was Ellison Myers "Tarzan" Brown, a feted long-distance runner who competed in every Boston Marathon between 1934 and 1946. He won twice, in 1936 and 1939, and was also a participant on the American team in the 1936 Olympic games in Berlin. As sports historian Tom Derderian wrote in his book about Brown: "The economy in these depression times provided little for most Americans and nothing for Indians…Brown…saw running as his only way out of poverty."[144]

The efforts of the Narragansett and other tribes to educate the public about Indian culture and obtain political support for reform in Indian management were interrupted by the advent of the Second World War. By this time, those Narragansett who had remained in Brothertown found themselves in an impoverished community, with no federal or state support to sustain them. Many moved away to where defense plants were operating, including Rhode Island, where Charlestown utilized Indian workers to assist naval contractors in building the cluster of fortifications that pointed antiaircraft and antisubmarine guns toward the bay.

Some Narragansett enlisted and became part of the twenty-five thousand Native Americans who served in the armed forces during the war, though even their enlistment, at the start of the conflict, was cause for debate. There were those in Congress, when passing the selective service act, who advocated for segregation—that all-black and all-Indian units be established—but the Roosevelt administration ignored that debate. Native American who enlisted served in integrated units throughout the war.[145] It has only been recently that the Native American contribution to the war has materialized, in the stories of the Cherokee code-talkers and individual acts of bravery and heroism. Among those Native American veterans is John A. Hopkins Sr., who enlisted in Charlestown but found his name absent from the five-foot marker commemorating those who served that was erected by town officials after the war. It took Charlestown forty-six years to correct the error, and by that time an embittered Hopkins had long left town.

The years after the war settled in slowly as the Narragansett returned to their former lives in Charlestown as farmers or farmhands, carpenters, stone artisans and road workers. It was a time of integration rather than individualism and a relatively peaceful time as remembered by Ellen Brown.

Artisans like Russell Spears continued traditions of Narragansett craft. A Narragansett born in Providence, Spears found himself working in Kenyon Dye Mills as a young man but was restless to be working with his hands outdoors. He left the mill and went to work with uncles and other relatives who were masons and learned the craft that tradition says had begun with Stonewall John. Spears built stone walls, patios and fireplaces and worked on buildings in Rhode Island, Connecticut and Cape Cod for nearly seventy years, teaching his sons to shape and carve rock. Spears's work became distinctively his own, renowned for its craftsmanship and unique in individual touches, an etching or portrait within the stonework. His legacy was recorded in the 2008 documentary film *Stories in Stone*.

It was also during this time after the Second World War that Congress passed PL 280, an act "empowering any state by an act of its own legislature to take over civil and criminal jurisdiction on Indian reservations, without consent of the tribes."[146]

Individual states made efforts to take tribal lands and strip tribal authority, as Rhode Island had done long before, in exchange for citizenship. But as Narragansett and other tribes had found, the long-harbored prejudice and distrust made it a citizenship with limited rights. It was not until 1953 that Native Americans in Maine not under federal jurisdiction were given the right to vote.

That same year, a Joint Congressional Resolution for the federal termination of Indian lands was heard with the aim "to end their status as wards of the United States, and to grant them all the rights and prerogatives pertaining to citizenship." Despite their hopes for a quick solution to the remaining "Indian problem," repatriation of lands would take more than thirty years to complete, with hundreds of cases heard around the country.

Chapter 20
Reclaiming Sovereignty

By the 1960s, the prevailing winds had changed, and Native American affairs began to be seriously viewed by the Kennedy and Johnson administrations. The federal government passed the Repatriation Acts, allowing tribes to petition state and federal museums for remains and artifacts. Indian affairs began to get more press in the growing medium of television, and protests by Native Americans became national and local news.

"The Narragansett kept living and acting as they'd always done," said preservation officer John Brown. "The times changed, and suddenly people were interested in the Narragansett again."

There is no doubt, however, that Native Americans became empowered by these changes and more visible and vocal in local and national protests. Members of the Narragansett were involved with the National Day of Mourning, established in 1970 by the United American Indians of New England (UAINE), which has continued in various form of protest—some of which are confrontational, such as the celebrated "burying" of Plymouth Rock by Native Americans and the alleged police force that was used to break up the demonstration in 1997 in which twenty-five people were arrested and numerous others were pepper-sprayed. The origin of this show of force seems to have been the Wampanoag lack of a permit, despite the tradition having been held for the last twenty-eight years.[147] Most protests on the National Day of Mourning have been solemn occasions from the gathering of Wampanoag and representatives from other tribes on Coles Hill, across from the harbor in the shadow of the bronze statue of Massasoit.

In January 1975, the Narragansett filed suit against the private owners of former tribal lands in Charlestown to gain possession of some 3,200 acres that the Narragansett cited as aboriginal territory. The land had been confiscated and sold by the State of Rhode Island just seven years after stripping the remaining Narragansett of their tribal status. Ninety-two years later, a repopulated and rejuvenated tribe based the suit on the supposition that the state had taken the land illegally and, in selling the land, had broken a federal law enacted in 1790.

For three years the state and the Narragansett prepared their cases; arguments and evidence from both sides of the issue are held in the Rhode Island Historical Society. Among the documents in the Edwards and Angel legal files and the Paul Campbell research notes for the law firm of Tillinghast, Collins and Graham are the documents that indicate what would have been a long and protracted battle.

The Narragansett prepared to exhibit as evidence the numerous deeds that had been drawn up with both the state and private parties from 1709 on into the nineteenth century, as well as the petitions the tribe had sent to the state regarding the sale of their lands. There are minutes from tribal meetings dating back to 1850, personal correspondence and the report of the commission on the affairs of the Narragansett Indians made to the General Assembly of January 1881 that includes a list of the 324 individuals accepted as tribal members. The basis of their claim rested on the argument that the state's sale of their aboriginal lands had been without federal consent, which violated the Trade and Intercourse Act of 1790: "No purchase, grant, lease, or other conveyance of lands, or of any title or claim thereto, from any Indian nation or tribe of Indians, shall be of any validity in law or equity, unless the same be made by treaty or convention entered into pursuant to the Constitution."[148]

The state, by contrast, seemed prepared to argue an echo of the nineteenth-century view of the tribe, relying on old histories and documents supporting the original design of detribalizing the Narragansett and integrating them as citizens of the state. In papers published by two of the legal counsel for the state ex facto, we see largely a resurgence of old arguments and explanations that indicate the state's preparedness to defend legislation from a century before, despite the tribe being federally recognized.

In his article "Scattered to the Winds of Heaven—Narragansett Indians 1676–1880" Glenn Lafantasie attempts a reconciliation of the traditional

white history of the tribe and the "red man's myth" as written by Fred Brown in a 1935 edition of *Narragansett Dawn* and summarized as follows:

> *The red man's myth claims that Narragansett warriors and the largest part of the Indian population were away from the fort.*[149] *Thus the Narragansetts…eventually became the dominant people comprising the Indian community in Charlestown, Rhode Island. This community then carried on traditions and customs of the Narragansetts, and although many Indians were later forced to intermarry with black slaves, and although whites forced Indians to partially assimilate into white society, the traditions of the Narragansett tribe persisted and remained virtually intact throughout the following three hundred years of history.*[150]

While this version of Narragansett history remains close to the oral history given today by the tribe, the scholars set out to debunk the "myth" through the use of those same arguments that led to detribalization.

First, the author claims irrefutably that the "aboriginal oasis" situated in Charlestown and Westerly "were the lands of Ninigret, sachem of the Niantics…perhaps the largest remaining indigenous group of Indians left in southern New England"; they further state that "[b]y the end of the seventeenth century the surviving Indian population in what was then called Narragansett country was an aggregate of peoples." Such statements would appear to refute any Narragansett claim to the lands in question.

The subject of integration is also raised again, with the author's contention that as early as 1790, when "political factionalism had virtually stagnated the Indians attempt to govern themselves" and the first efforts at control were taken by the state, "Narragansetts…had already undergone numerous cultural and societal changes…Indians in Rhode Island were beginning to work their way into the white marketplace…more and more Indians were following trades and livelihoods not traditionally Indian."

However, the trades of stonemasonry, carpentry and farm labor mentioned by the authors were part of the Narragansett "traditions" for at least a century before the time the scholars claim—and certainly when Narragansett were forced to work as indentured servants or those who chose that role in exchange for pay. It was not necessarily integration by choice. Nonetheless, "[s]uch changes, coupled with rampant internal factionalism,

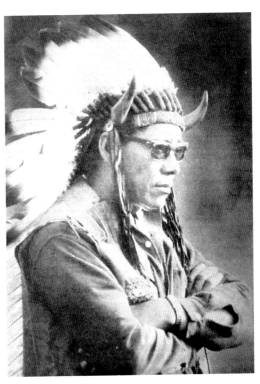

Medicine Man Lloyd Wilcox at the ceremony that repatriated nine hundred acres of land to the tribe. *Courtesy of the Warwick Historical Society.*

led the assembly to believe that Narragansetts were on their way toward entering the mainstream of white society."[151]

This coupling of the political view of the tribe's internal affairs and the state's "civic sense" of what is "best" for the Narragansett has always and continues to be interwoven into the fabric of relations with the tribe and, thus, the posturing and policy disputes that have dominated in recent years.

In 1978, mostly at the behest of the Town of Charlestown, the State of Rhode Island and the town reached a Joint Memorandum of Understanding (JMOU) with the Narragansett, granting 1,800 acres of land, taken evenly from private parties and state lands, along with a lump sum payment based on the present fair market value of other lands.

In return, the Narragansett tribe relinquished any legal claim to the 3,200 acres of aboriginal lands and agreed that "the settlement lands shall be subject to the civil and criminal laws and jurisdiction of the State of Rhode Island."

This clause would resurface time and again in the years that followed in confrontations, legal and otherwise, with the state.

Chapter 21
The Fight for a Casino and Economic Independence

Narragansett management of these lands has met with many challenges and been involved with numerous lawsuits against the state and federal governments, as well as suits against individual towns in relation to construction projects and private developers within and outside the Narragansett community.

Perhaps the most contentious dispute in recent years has been that of the Narragansett efforts to bring tribal gaming to the community. In 1988, the federal government had passed the Indian Gaming Regulatory Act "to provide a balance between the tribe's interest in autonomy and the states interest in protecting their citizens from the organized criminal activity that is commonly associated with the gaming industry. Furthermore, Indian gaming was viewed as a means of promoting the twin goals of strong tribal government and tribal economic self-sufficiency."[152]

IGRA separated Indian gaming into three separate classes that ranged from "social games solely for prizes" or "traditional forms of Indian gaming" such as those that occurred at yearly gatherings or powwows to "games of chance" such as bingo or card games. A third-class high-stakes or casino gambling would only be permitted on tribal lands that are "(1)…located within a state that permits gambling for any purpose by any person or organization; (2) the tribe adopts a gaming ordinance that has been approved by the chairman of the National Indian Gaming Commission; and (3) the activities are conducted in conformity with a tribal-state compact."[153]

The pursuit of Indian gaming rights for the Narragansett initially divided the tribe. Details of a lawsuit filed early on revealed a struggle between elders of the tribe, who opposed gambling as a means to a tribal economy, and a younger faction, who saw gaming as an opportunity for growth to other, independent tribal businesses.

The suit developed out of a 1985 agreement between the Narragansett Tribal Council and a Texas partnership called RIBO that would lend the tribe the funds needed to purchase two parcels of land and erect a high-stakes bingo hall.

As representatives from the Texas partner had met only with the tribal council, members of the tribe opposed to gaming on Indian land rose in protest and used the issue to promote a slate of antigaming candidates for upcoming tribal elections. When those candidates won election, and the results were approved by the Federal Bureau of Indian Affairs, the new tribal council filed suit to void the agreement. Former members of the tribal council countersued, but their motion to intervene was denied in the U.S. Court of Appeals.[154]

Despite these early disputes and reservations about Indian gaming by tribal members, the issues were effectively resolved within the tribe in a relatively short time, and the Narragansett have shown a united front in their efforts to gain gaming rights.

In July 1992, the Narragansett served the governor of Rhode Island with a letter requesting the state to enter into negotiations with the tribe for a compact that would allow the tribe to operate high-stakes gambling on their lands. The state responded by filing suit in the United States District Court contending that the provisions of IGRA did not apply to the settlement lands and that the Narragansett lands, under the previous 1978 agreement, were "subject to the criminal, civil, and civil regulatory laws of Rhode Island and the town of Charlestown."[155]

The suit centered on a thirty-one-acre site that the Narragansett had purchased for housing and economic development. When hardship caused planned projects to remain unfinished, the tribe appealed to the Department of the Interior to take the land into Indian trust, and thus this parcel would be subject to federal and tribal rather than state law. In 1993, the district court ruled against the state, and the following year, in the U.S. Court of Appeals, the state lost again.

After the court's ruling, then governor Bruce Sundlan signed an agreement with the tribe to negotiate for casino rights, but as this was signed during his last months in office, the next governor, Lincoln Almond, quickly filed suit to terminate the agreement. The court agreed, citing that under the Rhode Island Constitution, the governor held no power to "enter into any compact establishing a lottery operation or gaming facility in the state. That power was specifically vested in the General Assembly."[156] An important federal case just weeks later proved to be another setback, when the Supreme Court reached a decision based on its interpretation of limits on the federal government enforcing the Indian Gaming Rights Act that had allowed tribes to sue states in order to compel them to negotiate in "good faith" for gaming rights. The tribe amended plans for a Class II Bingo Hall that fell within the guidelines of IGRA and submitted a gaming management contract to the Indian Gaming Commission.

Rhode Island's Congressional delegation, led by Senator John Chafee, remained adamantly opposed to any Indian gaming facility in the state and set out to amend the 1978 settlement with the tribe, declaring that the Narragansett relinquished any rights granted by future federal legislation and that "[f]or purposes of the Indian Gaming Regulatory Act settlement lands shall not be treated as Indian lands."[157] The amendment made Indian gaming in the state possible only through inclusion of a referendum on the state ballot and voter approval.

Senator John McCain, then chairman of the Senate Committee on Indian Affairs, stated his disapproval of any attempt to amend the state's original agreement and suggested that a hearing be held for the proposed amendment. But no hearing was held, and the "Chafee Amendment," as it came to be known, was attached by the seasoned Rhode Island senator to a critical appropriations bill and passed with little individual attention.[158]

In the years that followed, two-term governor Almond set in motion the state's reliance on revenues from existing venues, which lately have come to prove costly with the legislative end of dog racing and falling revenue from slot machines. In the meantime, the Mashantucket Pequot and Mohegan tribes successfully opened resort casinos in neighboring Connecticut, and the Wampanoag began the long effort to establish a casino in Massachusetts.

Under the leadership of Matthew Thomas, a newly elected sachem who had diligently studied the gaming laws and prepared for the rough-and-

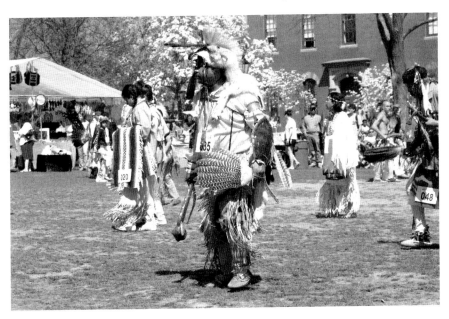

Chief Sachem Matthew Thomas leads a group of Narragansett dancers in a recent powwow at Brown University. *Photo by James M. Allen.*

tumble politics of Rhode Island, the tribe sought to build a casino in West Greenwich. Though they managed to get a referendum on the ballot, the Indian casino was rejected by voters.

In 1997, the Narragansett filed suit against the National Indian Gaming Commission in order to compel the commission to review its proposal, which it had denied review, citing the Chafee Amendment. The suit challenged that the amendment was a violation of equal protection (i.e., that the tribe was "singled out" from other tribes by the amendment preventing them from gaming rights). The suit was rejected in the Washington, D.C. District Court.

The struggle for gaming rights continued with the Narragansett partnering with longtime business partner Capital Gaming International. The plan called for a casino in West Warwick, and Sachem Thomas presented a public unveiling of the proposal in early 1999. At the time, the tribe's proposal was well received, and Thomas told newspaper reporters that "it was so refreshing to have a productive, open dialogue with the people of this community."[159]

The optimism was not to last. Capital Gaming soon began failing, and an additional cloud came over the proposal when the tribe spent some months looking for other investors. When the Narragansett partnered with

Boyd Gaming of Las Vegas and proposed an even more lavish venue, voters became nervous. In the end, legislators killed the bill that would have placed the casino on the November 2000 ballot.

Two years later, Thomas and the Narragansett tried once again to get the casino question on the ballot. Legislators opted this time to place the bill aside and create a Gaming Study Commission to report on "the desirability of further gaming" in the state.

In 2003, the state's Lottery Commission approved an increase of nearly two thousand slot machines at the Lincoln and Newport gambling venues, which contributed to Rhode Island's coffers.

By 2004, the Narragansett had partnered with Harrahs, the nation's third-largest casino operator and proposed a resort-style casino in West Warwick. Thomas and representatives from Harrahs met with senators at the statehouse and outlined the proposal that they estimated would generate $114 million for the state in its first year and offer $20 million annually for the tribe. The proposal called for the Narragansett to buy the casino from Harrahs after twenty years of operation. It was by far the most ambitious and well-underwritten proposal the tribe could have offered.

Once again, though, opposition to an Indian gaming casino rose in Rhode Island. A "Save Our State" coalition was formed that included the State's Council of Churches, the Greater Providence Chamber of Commerce, the Rhode Island Tourism Board and others. The coalition was fueled by financing from the owners of the Lincoln Park and Newport Grand casinos, which paid for a barrage of television commercials evoking the dark side of gambling and questioning whether Rhode Islanders were prepared for the hundreds of millions of dollars in revenue the state would lose from the draw a Narragansett casino would create.

The referendum was defeated in 2006. Since that time, the owners have renovated the Lincoln venue, now called Twin Rivers, with restaurants and an entertainment center that were part of the Narragansett proposal (which the Lincoln owners warned would take away revenue from Providence landmark theaters and restaurants).

In the courts, it could be said that the efforts to build a tribe-run casino came full circle and culminated in 2009 with the United States Supreme Court finding in favor of the State of Rhode Island in *Carcieri v, Salazar* regarding that thirty-one acre parcel of land that had begun the battle. In the

state's appeal of the U.S. District Court's opinion, the Supreme Court ruled that tribes who achieved federal recognition after the Indian Reorganization Act of 1934, by which lands could be placed in trust, were not subject to those privileges that the act instated—opening the door to a wave of lawsuits from the three hundred tribes who found themselves in similar straights as the Narragansett.

Chief Sachem Thomas vowed to fight the court's decision. "Apparently, the illegal actions of the state weren't of consideration to the Supreme Court," he told a *Journal* reporter. "How are you ignoring something that's been here for hundreds of years?...That to me which is history can't be ignored."[160]

For the twenty-four years that the Narragansett pursued gaming rights, very little came of the struggle except for legal fees and the wealth of information and cases for students and scholars to place into some perspective.

As of this writing, the Narragansett have appealed to the state's U.S. senators after the Committee on Indian Affairs approved legislation that would effectively overturn the Supreme Court's ruling. The Rhode Island delegation of Senators Reed and Whitehouse has been reluctant to add its support, even with Thomas's reassurance that the site would once again be used for elderly housing.

Other efforts to gain the tribe some economic independence have met with mixed results. Eleanor and Ferris Dove created the Dovecrest Restaurant and Trading Post, which was highly successful and eventually world renowned. Their efforts to offer Narragansett culture and cuisine to the wider world resulted in the Tomaquag Indian Memorial Museum and the Nuweetooun School, which brings the story of "the state's original inhabitants" to hundreds of children across the state each year. The museum's exhibits and ceremonies attract visitors from around the globe. The annual powwows presented with other Indian tribes in friendly competition also draw crowds of people interested in learning of local Native American culture.

A proposal to create an "Indian Village" on the model of Plymouth Plantation met resistance from town officials, and the idea was eventually abandoned. Another project to grow and distribute "beefalo" met with similar resistance from neighbors and the town.

Chief Sachem Thomas met with Governor Carcieri several times, the most notable time in June 2003, when he toured the reservation "to get a

sense of the economic stress" the Narragansett were facing.[161] Despite the governor's apparent interest, there was little further communication until July, when the tribe opened a smoke shop out of a long trailer parked off Main Route 102 on tribal land. Carcieri was out of state the weekend the shop was opened but spoke with Thomas by phone, insisting that the tribe must collect state taxes from any business on their land.

Thomas reputedly offered to close the shop if the governor dropped his opposition to casino gambling, though that is highly speculative. What the sachem did promise was to take the issue to court, but before any motion could be filed, the state sent in thirty troopers to raid the smoke shop on Monday afternoon in an ugly melee that was broadcast throughout the state and nationwide.

Eight tribal members were arrested, including Sachem Thomas, who had been pushed to the ground and handcuffed during the skirmish. That evening, after spending some hours in the Hope Barracks, Thomas compared the treatment of the Narragansett to that of blacks in the South during the

A site marker of Narragansett lands in Charlestown. *Photo by author.*

civil rights era and complained again that the state refused to recognize the federal status of the tribe.

"The state made a huge mistake today, and that will be proven," he told tribal members. In the weeks that followed, the footage of the raid drew the ire of civil groups, as well as other Native American tribes. The NAACP gave Thomas its highest honor some months later for "fighting for his people." Nearly four years after the raid, those arrested were found guilty of misdemeanor charges; however, Thomas and codefendant Hiawatha Brown were convicted of simple assault.

Chapter 22
A Legacy on the Land

O versight of Narragansett lands is presently in the hands of tribal preservation officer John Brown, who must assess the impact of local projects and confirm new finds at development sites as Narragansett property, engaging the complex and sacred process by which tribal remains are removed before developers can return. This role in the tribe has often placed him in a contentious position with local developers and utility engineers, as well as anthropologists and historians.

Anthropologists involved with a long-running dispute over artifacts found at Burr Hill in Warren Rhode Island contend that Brown has an inflated sense of the Narragansett with respect to neighboring tribes. But in conversation, Brown alludes to the centuries during which Narragansett were a thriving people within a vast territory. He has been praised by the state's archaeologist, Paul Robinson, for his efforts in educating state officials about historic sites. "I think he's taught us that sometimes we walk a fine line between preservation and excavation, and sometimes it's better to wait and preserve than to excavate," Robinson told the *Providence Journal*.[162]

In October 2009, Brown received the Frederick C. Williamson Leadership Award from the state's Historic Preservation and Heritage Commission. The executive director, Edward Sanderson, acknowledged that he and Brown did not always see eye to eye. "We look at some issues from different perspectives," he told the *Providence Journal*, but he also praised Brown for his role in preserving the traditions and the cultural values of the Narragansett, as well as for his careful consultation with Lloyd Wilcox, the tribal medicine

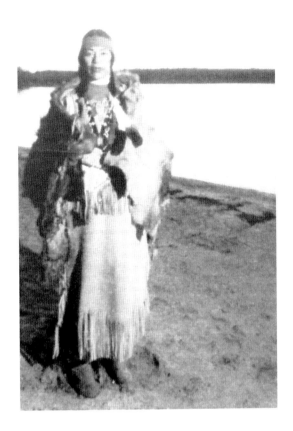

Tribal ethnohistorian and medicine woman Ella Sekatau, seen in this photo on the shore of Wachaug Pond. *Courtesy of the Warwick Historical Society.*

man, and other elders of the tribe. In presenting the award to Brown, Sanderson told those assembled that "[a]t a time when Native Americans were routinely left out of historic preservation, John made sure that a Narragansett voice was heard."

Another Narragansett voice that has resonated over the years has been that of Ella Wilcox Sekatau, the tribe's ethnohistorian. In her role, Sekatau has collaborated through oral history with scholars and historians who have published numerous books and papers on aspects of Narragansett life. In this way, Sekatau has ensured that a more accurate history is read by professors and students and discussed in classrooms across the nation.

On college campuses, interest in Native American studies is flourishing, including in Rhode Island, where developments would indicate that there is still much to be studied about these indigenous people.

An early map documenting Narragansett sites located around Point Judith Pond, 1923.
Courtesy of the Rhode Island Historical Society.

Because the Narragansett occupied and traveled in such a vast area of land, evidence of their encampments, as well as burial sites, continues to be found in the state.

Perhaps the largest, and still most significant, of these sites would be the settlement discovered just east of Point Judith Pond, a location eyed by developers for a seventy-nine-unit housing complex. Workers from Rhode Island College were directed to make the obligatory cursory examination for artifacts in the fall of 1986 and found evidence immediately that over the years was revealed to be a twenty-five-acre settlement that included the remains of Narragansett dwellings and circular storage pits for corn and other staples.

The discovery of this site was, in fact, one of the most extensive ancient seaside settlements found on the eastern coast of North America. Another had been excavated in Virginia some years earlier and is now on the National Register of Historic Places. Though privately owned, the area is protected under Virginia and federal statutes.

In Rhode Island, however, a long and protracted legal battle between the state and developers has taken place. The State Historic Preservation Commission, with the Narragansett looking over its shoulder, argues for the significance of the site as "a site of great importance that would be studied by several generations of scholars."[163]

Initially, the project was stalled by state demands that the developers had to meet in searching for artifacts before proceeding. These searches led to more discoveries, including an Indian burial ground. Excavations in 2006, paid for by developers who had returned to the site to lay a road, unearthed evidence of twenty-two dwellings. These findings led the Historic Preservation Commission to request that the permit issued to developers in 1992 be withdrawn. Developers responded by filing suit, asking the courts to end the state's interference and asking for "substantial damages" for the long delay.

While the Narragansett did not take an active role in these proceedings, the tribe naturally supported the state's efforts to preserve the land. Preservation officer Brown told the *Journal*, "The protection of the property is for everybody…we sympathize with the plight of the owners, but you can't trade history for a house or three houses…it would be like someone going in and building on the Arlington National Cemetery."[164]

Another notable site is Greene Farm, a small compound of houses and outbuildings overlooking Occupessatuxet Cove, whose property dates from Miantonomo's sale of the land. Owned by the Brown family for several generations, it is now the site of an ongoing archaeological dig sponsored by the university that bears the family name.

Henry A.L. Brown, a descendant of Governor John Brown Francis, presently resides on the Spring Greene farm; he told me that he and his brother discovered many artifacts during the days of their youth. A local historian who has written of the early days of Warwick, Brown remembers that his father and grandfather often repeated legends of an earlier generation and took the boys to the beach or in newly plowed fields to look for arrowheads. They pointed out Mark Rock on Occupessatuxet Cove with its petroglyphs and the general location of the "Indian wadding's," an ancient trail of the Narragansett's leading from Conimicut to the Pequot trail, which crossed the salt marshes on the farm. In 1944, in a newly plowed piece of meadow was uncovered a number of stone bowls, dishes, pestles and mortars made of steatite (soapstone). The stone articles were gathered by Henry's father and safely stored in the feed box of the elegant John Brown chariot, purchased by the famous Providence merchant in Philadelphia in 1782. The chariot was donated by the Brown family to the Rhode Island Historical Society in November 1945. The elegant carriage was transported to Providence on a flatbed truck and stored in the coach house adjacent to the John Brown house museum on Power Street. Two weeks later, Henry's father recalled having stored the Narragansett artifacts in the chariot and drove to Providence to recover the items, but to no avail. The artifacts were gone.

At the time of this writing, the archaeological dig has been ongoing since 2004, and six years later so many artifacts have been found that the summer was spent cleaning and cataloguing what lay spread out on makeshift tables in a large barn.

Some sites have been found quite recently and often in unexpected places, as when Narragansett remains were found in the cellar of a colonial-era home in Warwick. As recently as 2009 in Warren, where such long excavations had already taken place, yet another area of Burr's Hill yielded fresh artifacts. No doubt more relics of Narragansett life and culture will be unearthed in the years to come, further evidence that this proud people were once and always will be keepers of the bay.

Notes

Chapter 1

1. It is extraordinary that Canonicus lived to meet both Verrazzano and Williams. He would have been well over a hundred when he met the latter. Preservation officer John Brown tells me that it is still not uncommon today for Narragansett to live over a century. Indeed, Samuel Drake in his *Indians of North America* recounts meeting a Narragansett medicine man near "Little Falls" in Pawtucket who was reputed to be "two hundred years old."

2. For an excellent telling of the breakdown of this long tradition, see Gary Nash's *Forbidden Love*.

3. Rubertone, *Grave Undertakings*, 75.

4. Cotton Mather, *Magnalia Christi Americana*.

5. In late 2009, while preparing for construction along Water Street, the remains of another Narragansett graveyard were found in Warren. The site is adjacent to Burr's Hill, long rumored to be the burial place of Ousamaquin. In Warwick also, in the Lakeville neighborhood, the skeletal remains of a Narragansett were found in the dirt cellar of a home built in the late 1800s.

6. Rubertone, *Grave Undertakings*, 80.

7. Williams, *A Key*, 80.

8. An earlier visit to the Narragansett by Edward Winslow of Plymouth Colony caused the visitor to write of his belief that the "Nanohiggansets [Narragansett] eceede in their blinde devotion…Thither at certain knowne times resort all their people and offer almost all the riches they ha[v]e to their gods, as kettles, skins, hatchets, beads, knives, & c., all which are cast by their priests into a great fire that they make in the midst of the house and there consumed to ashes. To this offering e[v]ery man bringeth freely, and the more hee is knowne to bring hath the better esteeme of all men."

CHAPTER 2

9. Ellis and Morris related the episode more fully. In their version, Stone and others kidnaped two natives, bound them and forced them to guide his craft up the river. Other natives, having witnessed the kidnaping, followed the craft and waited until night to kill Stone and his comrades and rescue the victims. *King Philip's War*, 25.

10. Adams, *Founding of New England*, 200.

11. Rubertone, *Grave Undertakings*, 76.

12. Ibid., 77–78.

CHAPTER 3

13. Leach, *Flintlock and Tomahawk*, 14.

14. Uncas was born a Pequot but in adulthood rebelled against Sassacus, the tribe's sachem, and was banished. He took a gathering of other discontented Pequot and called them by the tribe's ancient name of Mohegan. Ellis and Morris, *King Philip's War*.

15. Winthrop, *Declaration of Former Passages and Proceedings*.

16. Gardiner, *Leift Lion Gardiner His Relation of the Pequot Wares*.

17. Ibid.

18. Winthrop, *Declaration of Former Passages and Proceedings*.

19. Burton, "Hellish Fiends and Brutish Men," 236.

20. Letter to General Court, May 25, 1644, from *Declaration of Former Passages and Proceedings*.

21. Winthrop, *Declaration of Former Passages and Proceedings*.

22. Ibid.

23. Ibid.

24. Winthrop, Journal 2, 156, Winthrop Papers, Massachusetts Historical Society; Roger Williams to John Winthrop, June 25, 1645, Letters of Roger Williams, 145.

25. DeForest's *History of the Indians in Connecticut* is the only source I've found for this engagement, referenced in Burton's dissertation.

CHAPTER 4

26. Samuel Willard, ed., Acts of the Commissioners of the Massachusetts Bay Authority 10:146–48.

27. Burton, "Hellish Fiends and Brutish Men," 241, referencing a letter from Roger Williams to John Winthrop Jr., October 24, 1649.

28. Letter of Robin Casasynomon to John Winthrop Jr., May 5, 1669.

29. Hubbard, *History of the Indian Wars*.

30. Hutchinson, *History of the Colony of Massachusetts Bay*, vol. 1, notes from page 281.

31. Adams, *Founding of New England*, 348.

Chapter 5

32. Adams, *Founding of New England*, 349.
33. Sassamon was found beneath the ice of Assawompsett Pond on January 29, 1675, when a group of Indians passing by the pond noticed his hat and gun resting on the ice on the surface. As Sassamon had reported that Metacom was organizing an uprising to authorities only days before, suspicion immediately fell on the Wampanoag.
34. Leach, *Flintlock and Tomahawk*, 28.
35. Increase Mather, *Brief History of the War*, 52.
36. The sachems, in fact, may not have trusted Smith, apparently with good reason. Just a few months later, he would house militia on their way to the Great Swamp.
37. Now commonly known as Worden's Pond, just beyond the Great Swamp territory.
38. Rubertone, *Grave Undertakings*, 91.
39. Adams, *Founding of New England*, 353.
40. Chapin, *Sachems of the Narragansett*.
41. Increase Mather, *Brief History of the War*.
42. Gerald Hyde's remarks written for the occasion of the dedication of the stone memorial installed in 1938.
43. Leach, *Flintlock and Tomahawk*, 128.
44. Letter of Captain Oliver, Narragansett, November 26, 1675, http:// bigelowsociety.com/rod/battles.htm.
45. I would recommend to the reader, however, the particularly poignant telling by Leach in *Flintlock and Tomahawk*, as well as in Philbrick's modern retelling in *The Mayflower*.

Chapter 6

46. This is a typical summary of Narragansett life in the aftermath of the war and in the nineteenth-century historian's viewpoint.
47. Bradford, *History Of Plymouth Plantation*, 78.
48. Chapin, *Documentary History of Rhode Island*, 101–2.
49. Ibid.
50. Ibid., 124.
51. Ibid., 149.
52. Ibid., 158.
53. Bailyn, *Peopling of British North America*.
54. Sainsbury, "Indian Labor in Early Rhode Island."

Chapter 7

55. Conforti, *Saints and Strangers*, 151.

CHAPTER 8

56. This was a lesson apparently learned from Connecticut's distribution of native slaves after the Pequot War.

57. Sainsbury, "Indian Labor in Early Rhode Island," 383.

58. Sidney S. Rider, *Book Notes*, Rhode Island Collection Rec., vol. II (Providence, Rhode Island), 535; Miller, in his *Narragansett Planters*, notes that the earlier law of 1652 "prohibiting the holding of negroes or Indians as slaves for longer than ten years, would seem to have become a dead letter."

59. Miller, *Narragansett Planters*, 21.

60. *Providence Gazette*, November 6, 1773.

61. Channing, "Narragansett Planters."

62. A description included in the footnotes of Miller's *Narragansett Planters* bears reprinting here: "They have handsome foreheads, the head clean, the neck long, the arms and legs thin and taper…They are very spirited and carry both head and tail high."

CHAPTER 9

63. Quoted in "Retelling Narragansett Lives," chapter 7 of *Grave Undertakings*, 141.

64. Simmons and Simmons, *Old Light on Separate Ways*, 21–22.

65. Brown, *Life of William J. Brown*, 4.

66. Letter from James Deake to Reverend Joseph Fish, quoted in Mandell, *Tribe, Race, History*, 54.

67. Chapin, *Documentary History of Rhode Island*, 170–71.

68. Deposition of Indian Hannah, March 3, 1729, for the Rhode Island Supreme Court.

69. Stiles's comment came from Indian accounts given to him.

70. Rubertone, *Grave Undertakings*, 142.

71. Herndon and Sekatau, *Right to a Name*, 440.

72. Fitts, *Inventing New England's Slave Paradise*.

73. Ibid.

74. The site of Miantonomo's burial was one such site, visited regularly on the anniversary by hundreds of Narragansett who would drop a stone on a cairn that was finally dismantled by the town and replaced with a cement monument in 1841.

CHAPTER 10

75. Account written by Elizabeth Brenton in the *Newport Mercury* of August 13, 1853, from family records.

76. Chapin, *Early Records of the Town of Warwick*, 80–81.

77. Drake, *Old Indian Chronicles*, 300.

78. Callendar, *Historical Discourse*.

79. Gookin, *Historical Collections of the Indians of New England*.

80. Letter of Henry Bouquet to General Jeffrey Amherst, October 24, 1763.
81. Johnson, "Search for a Useable Indian," 629.
82. Collins, *Muster Roll of Newport County Troops.*
83. Calloway, *Algonkians in the American Revolution*, 59.
84. Hohman, *American Whaleman.*
85. Ibid., 23.
86. Ibid., 24.
87. Herndon and Sekatau, *Right to a Name*, 440.
88. Ibid., 442.
89. Ibid.

CHAPTER 11

90. The petition was signed on December 18, 1769.
91. Williams, *A Key*, 123.
92. Ibid., 56.
93. Simmons, "Red Yankees."
94. Many Indians had converted in Stonington the year before after Reverend James Davenport's powerful meetings in 1741.
95. Simmons, "Red Yankees."
96. Ibid., 262.
97. Simmons, "Red Yankees," 262.

CHAPTER 12

98. Sweet, *Bodies Politic.*
99. Simmons and Simmons, *Old Light on Separate Ways*, 4–5.
100. Ibid.
101. Ibid., 57.
102. Ibid., 80.
103. Ibid., 89.
104. Ibid., 110.
105. Brookes, *Collected Writings of Samsom Occom*, 294.
106. Chapin, *Sachems of the Narragansett*, 101.
107. From Coe's journal, reprinted in Mandell, *Tribe, Race, History*, 85.
108. Ibid., 86.
109. Simmons and Simmons, *Old Light on Separate Ways*, 10.

CHAPTER 13

110. Love, *Samson Occom and the Christian Indians of New England*, 353.
111. Footnote 55 from Herndon and Sekatau, *Narragansett People and Rhode Island Officials*, 459.

CHAPTER 14

112. I am referring, of course, to Samuel Niles (1674–1769), who did indeed visit the Narragansett church but was a guest, as was the Narragansett custom, and never an official "minister" to the congregation.

113. Updike, *History of the Episcopal Church*, vol. 1, 338.

114. Dennison, *Westerly and its Witnesses*.

115. Two towns actually bid for the books. After considerable negotiation, the town of Thurber changed its name to Bicknell, while the town of Grayson changed its name to Blanding, the maiden name of Bicknell's wife. Each town received five hundred books.

116. Narragansett Tribe of Indians, *Report of the Committee of Investigation*, 1880.

117. Ibid.

118. Ibid., 89.

CHAPTER 15

119. "Squaw Betty's Neck," as Thoreau reports, later called "Betty's Neck."

120. Thoreau, "Journals of 1837–1861," 389.

121. Sayre, *Thoreau and the American Indians*, 18.

122. Ibid.

123. Chapin, "Indian Graves."

124. Guilliford, "Bones of Contention."

CHAPTER 16

125. Parsons, "Indian Relics."

126. Wilder, "Notes on the Indians of Southern New England."

127. These, like other Narragansett remains, continued to travel. In 1966, Smith College gave the University of Massachusetts the remains, and by 2004, under the Federal Repatriation Act, the university was seeking claimants to the remains. The remains were finally returned to the tribe in 2005.

128. The property had been sold by Thomas Ninigret. The sale prompted Samuel Niles and his followers to petition the state to prevent the sachem from selling any more land.

129. This may have been Chapin's doing, as he was the librarian of the RIHS. It is likely that the board was persuaded by his long-standing argument as to the identity of the remains.

130. For the most recent updates on this sordid tale, I am grateful to Professor Steve Lubar for providing Annie Johnson's paper "The Forgotten Collection."

CHAPTER 17

131. Wilder, *Notes on the Indians of Southern New England*, 210.
132. Long thought to be of Dutch origin—and, to some speculation, English—these claims of a European fortress are refuted by Leichester Bradner in the RIHS Collections (January 1921); he ventured that the fort was a historic Narragansett encampment, fortified with ammunitions from the long-standing Dutch trade with the Narragansett. Excavations in the 1970s unearthed two cannons of European origin, thus setting off the debate once again.
133. Rubertone, "Memorializing the Narragansett."
134. Ibid.
135. Great Swamp Fight monument, Rhode Island Society of Colonial Wars, 1906.
136. Ibid.
137. Ibid.

CHAPTER 18

138. Princess Red Wing in the *Narragansett Dawn*.
139. Chapin, "Queen's Fort."

CHAPTER 19

140. Howard M. Chapin's popular edition of *A Key to the Language of America* was printed in 1936, but parts were quoted liberally in Bicknell's *History of Rhode Island* and by Sidney S. Rider, another local historian and champion of *A Key* as a valuable resource on the Narragansett.
141. McMullen, "What's Wrong with This Picture?"
142. McMullen, "Soapbox Discourse," 57.
143. Paul Davis, "One Nation, Two Worlds, Part 4: Preacher Carries on 'the Call' Handed Down through Generations, "*Providence Journal*, August 4, 2004.
144. Derderian, *Boston Marathon*.
145. Nichols, *American Indians in U.S. History*.
146. Dennis, *American Indian*, 59.

CHAPTER 20

147. The Town of Plymouth reached an agreement with the Wampanoag the following year to waive the need for a permit as long as the tribe gave the town advance notice of a protest or gathering.
148. 25 USC S177 (1994).

149. A reference to the fort at Great Swamp that white histories have portrayed as the turning point of King Philip's War and the near extermination of the Narragansett people.
150. Rhode Island Historical Society, *Rhode Island History* 38 (1978): 68.
151. Ibid., 75.

CHAPTER 21

152. 25 USC 2701, as referred to in Berger, "Narragansett Tribal Gaming."
153. Ibid.
154. *Narragansett Indian Tribe v. Ribo Inc. G. Wilcox E.*, decided February 14, 1989, Rhode Island Court Documents, State Courthouse Library.
155. Ibid.
156. *Narragansett Indian Tribe of Rhode Island v. State of Rhode Island*, 667 A2nd280, 1995, Rhode Island Court Documents, State Courthouse Library.
157. 25 USC 1708 (b).
158. Berger, "Narragansett Tribal Gaming."
159. Paul Davis, "A Modern Chief," *Providence Journal*, August 1, 2004.
160. Katie Mulvaney, "Chief Sachem Matthew Thomas Says Tribes Will Fight Court Ruling," *Providence Journal*, February 26, 2009.
161. *Providence Journal*, August 1, 2004.

CHAPTER 22

162. Liz Abbott, "Persistence, Perspective Earn Brown Award," *Providence Journal*, December 6, 2009.
163. Statement made by Edward F. Sanderson, executive director of RIHPC, to the *Providence Journal* in its article on October 18, 2009.
164. *Providence Journal*, October 18, 2009.

Bibliography

Adams, James Truslow. *The Founding of New England*. Boston, MA: Little, Brown, 1923.

Axtell, James. *The Invasion Within*. New York: Oxford University Press, 1985.

Bailyn, Bernard. *The Peopling of British North America*. New York: Knopf, 1986.

Berger, Jana M. "Narragansett Tribal Gaming and the Indian Giver." *Gaming Law Review* 3, no. 1 (1999).

Bradford, William. *History of Plymouth Plantation 1620–1647*. Boston: Massachusetts Historical Society, 1912.

Brookes, Joanna, ed. *The Collected Writings of Samsom Occom, Mohegan*. New York: Oxford University Press, 2006.

Brown, William J. *The Life of William J. Brown of Providence, Rhode Island*. Lebanon: University of New Hampshire Press, 2006

Burton, William James. "Hellish Fiends and Brutish Men." Dissertation, Kent State University Doctorate Program in Philosophy, 1976.

Callendar, John. *An Historical Discourse of the Civil and Religious Affaires of the Colony of Rhode Island*. Charleston, SC: Nabu Press, reprint 2010.

Calloway, Colin G. "New England Algonkians in the American Revolution." *Algonkians of New England: Past and Present*. Edited by Peter Benes. Boston, MA: Boston University, 1993.

Channing, Edward. "The Narragansett Planters: A Study of Causes." Johns Hopkins University Studies IV, 1886.

Chapin, Howard. *A Documentary History of Rhode Island*. Providence: Rhode Island Historical Society, 1939.

——. "Indian Graves." *Rhode Island Historical Society Magazine* (January 1927).

——. "Queen's Fort." *Rhode Island Historical Society Magazine* (October 1931).

——. *Sachems of the Narragansett*. Providence: Rhode Island Historical Society, 1938.

Chapin, Howard, ed. *The Early Records of the Town of Warwick*. Providence, RI: E.A. Johnson Co., 1926.

Collins, Clarkson A. *A Muster Roll of Newport County Troops Sent Toward Albany in 1757.* Council of the Society of Colonial Wars. Publication no. 46. Providence, RI: Roger Williams Press, 1961.

Conforti, Joseph A. *Saints and Strangers: New England in British North America.* Baltimore, MD: Johns Hopkins University Press, 2006.

DeForest, John S. *History of the Indians in Connecticut.* Hartford, Connecticut, 1851.

Delabarre, Edmund B. *The Inscribed Rocks of Narragansett Bay.* Providence: Rhode Island Historical Society, January 1924.

Dennis, Henry C., ed. *The American Indian 1492–1976.* Ethnic Chronology Series 1. Dobbs Ferry, NY: Oceana Publications, 1977.

Dennison, Frederic. *Westerly and its Witnesses.* Providence, RI: J.A. & R.A. Reid, 1878.

Derderian, Tom. *The Boston Marathon: The History of the World's Premiere Running Event.* Champaign, IL: Human Kinetics, 1993.

Drake, Samuel G. *Old Indian Chronicles.* Boston, Massachusetts, 1867.

Ellis, George W., and John E. Morris. *King Philip's War.* New York: Grafton Press, 1906.

Fitts, Robert K. *Inventing New England's Slave Paradise.* New York: Routledge, 1998.

Gardiner, Lion. "Leift Lion Gardiner His Relation of the Pequot Wares." *Appendix to the History of the Wars of New England with the Eastern Indians.* Edited by Samuel Penhallow. Cincinnati, OH: William Dodge, 1859.

Gookin, Daniel. *Historical Collections of the Indians of New England.* Boston: Massachusetts Historical Society, 1792.

Guilliford, Andrew. "Bones of Contention: The Repatriation of Native American Human Remains." *American Historian* (1996).

Herndon, Ruth Wallace, and Ella Wilcox Sekatau. *Narragansett People and Rhode Island Officials.* N.p., n.d.

————. *The Right to a Name: The Narragansett People in the Revolutionary Era.* N.p., n.d.

Hohman, Elmo Paul. *The American Whaleman.* New York: Longmans, Green & Co. 1928.

Hubbard, William. *The History of the Indian Wars in New England.* Vols. 1 and 2. Roxbury, MA: W.E. Woodward, 1865.

Hutchinson, Thomas. *The History of the Colony of Massachusetts Bay.* Boston, Massachusetts, 1764.

Johnson, Annie. "The Forgotten Collection: Brown's Jenks Museum of Natural History." Brown University course paper, 2007.

Johnson, Richard R. "The Search for a Usable Indian: An Aspect of the Defense of Colonial New England." *Journal of American History* 64, no. 3 (December 1977).

John Winthrop Papers, 1630–1892. Boston, Massachusetts Historical Society.

Leach, Douglas Edward. *Flintlock and Tomahawk.* New York: Macmillan, 1958.

Love, William Deloss. *Samson Occom and the Christian Indians of New England.* Syracuse, New York: Syracuse University Press, 2000.

Mandell, David R. *Tribe, Race, History.* Baltimore, MD: Johns Hopkins University Press, 2008.

Mather, Cotton. *Magnalia Christi Americana: Or, The Ecclesiastical History of New England from its First Planting...* London: Thomas Parkhurst, 1702.

BIBLIOGRAPHY

Mather, Increase. *A Brief History of the War with the Indians in New England.* London: Richard Chiswell, 1676.

McMullen, Ann. "Soapbox Discourse: Tribal Historiography, Indian-White Relations, and Southeastern New England Powwows." *Public Historian* 18, no. 4 (Autumn 1996).

———. "What's Wrong With This Picture? Context, Conversion, Survival, and the Development of Regional Native Cultures and Pan-Indianism in Southeastern New England." *Enduring Traditions: The Native Peoples of New England.* Edited by Laurie Weinstein. Westport, CT: Bergin and Garvey, 1994, 123–50.

Miller, William Davis. *The Narragansett Planters.* N.p.: American Antiquities Association, 1934.

Narragansett Tribe of Indians. *Report of the Committee of Investigation; A Historical Sketch and Evidence Taken. Made to the House of Representatives at the January Session A.D. 1880.* Providence, RI: E.L. Freeman and Son, 1880.

Nichols, Roger L., and George R. Adams. *American Indians in U.S. History.* N.p.: John Wiley & Sons, 1975.

Parsons, Usher, MD. "Indian Relics." *Historical Register,* February 1863.

Philbrick, Nathaniel. *The Mayflower.* New York: Viking Press, 2006.

Providence Journal. Numerous articles as cited in notes.

Rubertone, Patricia. *Grave Undertakings.* Washington, D.C.: Smithsonian Institution Scholarly Press, 2001.

———. "Memorializing the Narragansett: Placemaking and Memory Keeping in the Aftermath of Detribalization." *Archaeologies of Placemaking.* Walnut Creek, CA: Left Coast Press, 2008.

Sainsbury, John. "Indian Labor in Early Rhode Island." *New England Quarterly* 48, no. 3 (September 1975).

Sayre, Robert F. *Thoreau and the American Indians.* Princeton, NJ: Princeton University Press, 1977.

Simmons, William S. *The Narragansett.* Broomall, PA: Chelsea House Publishing, 1989.

———. "Red Yankees: Narragansett Conversion in the Great Awakening." *American Ethnologist* 10, no. 2 (May 1983).

Simmons, William S., and Cheryl L. Simmons. *Old Light on Separate Ways: The Diary of Joseph Fish.* Lebanon, NH: University Press of New England, 1982.

Sweet, John Wood. *Bodies Politic: Negotiating Race in the American North, 1730–1830.* Baltimore, MD: Johns Hopkins University Press, 2003.

Thoreau, Henry David. "The Journals of 1837–1861." Boston, MA: Houghton, Mifflin, 1949.

Tucker, William F. *A Historical Sketch of Charlestown.* Westerly, RI: G.B. & J.H. Utter, 1877.

Updike, Wilkins. *The History of the Episcopal Church in Rhode Island.* New York: Henry M. Onderdonk, 1847.

Verrazzano, Giovanni. *Voyages.* N.p.: NTHS edition, 1938. John Carter Brown Collection.

Wilder, Harris Hawthorn. "Notes on the Indians of Southeastern New England." *American Anthropologist* 14, no. 3 (July–September 1912).

Williams, Roger. *A Key Into the Language of America.* 5th ed. Providence: Rhode Island and Providence Plantations Tercentenary Committee, 1936.

————. *Letters of 1632–82.* Providence, RI: Narragansett Club, 1874.

Winthrop, John. *Declaration of Former Passages and Proceedings Betwixt the English and the Narragansett, with Their Confederates.* Boston, Massachusetts, 1645.

Winthrop, Robert Charles. *Life and Letters of John Winthrop.* Boston, MA: Ticknor and Fields, 1867.

About the Author

R obert A. Geake has been a Rhode Island author and historian for more than thirty years. His articles, book reviews and stories have appeared in numerous publications. His articles on Native American history may be found on rifootprints.com. Mr. Geake is an associate of the John Carter Brown Library at Brown University and a member of the American Historical Association and the Rhode Island Historical Society.

Visit us at
www.historypress.net
...
This title is also available as an e-book